DELAWARE

D1501191

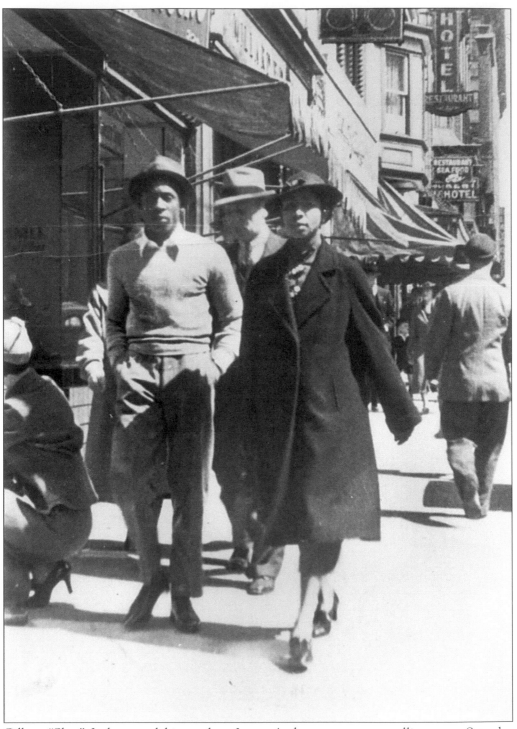

Gilbert "Slew" Jackson and his mother, Jenny Ambrose, are seen strolling on a Saturday afternoon down Market Street in Wilmington, Delaware.

BLACK AMERICA SERIES

DELAWARE

Jeanne D. Nutter, Ph.D.

ARCADIA

Published by Arcadia Publishing,
an imprint of Tempus Publishing, Inc.
2 Cumberland Street
Charleston, SC 29401

Printed in Great Britain.

Library of Congress Catalog Card Number: Applied for.

For all general information contact Arcadia Publishing at:
Telephone 843-853-2070
Fax 843-853-0044
E-Mail arcadia@charleston.net

For customer service and orders:
Toll-Free 1-888-313-BOOK

Visit us on the internet at http://www.arcadiaimages.com

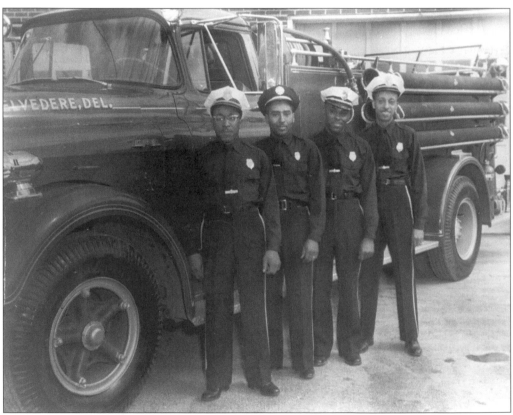

The Belvedere Fire Company was the first and only African-American fire company in the state of Delaware. This 1960s picture shows four officers who are, from left to right, Chief Edward Knotts, Captain Austin Sudler, Chief Thomas Bulah, and Chief James Gardner.

CONTENTS

Acknowledgments

This book is a small attempt to capture some of the rich heritage of the African-American past in Delaware. As I review the people and institutions that shaped a strong and proud community, I see clearly the dignity and strength of a people with a common purpose.

This project began while I was working on a documentary film, through the auspices of the Hagley Museum and Library, concerning African-American education in Delaware. I was having a difficult time locating a large collection of photographs of the African-American community. I realized that most of the materials we were seeking were in private collections. Slowly but surely, as I asked family and friends, the pictorial history began to emerge. The next challenge was editing this marvelous assemblage of images. Many wonderful photographs had to be eliminated because of a shortage of space. I apologize to anyone that I may have offended by omitting him or her. Please understand my dilemma. The following individuals have been generous in sharing their time and cherished personal collections. They have trusted me with their valuable and irreplaceable possessions. I will always be indebted to you. I would like to especially thank Reverend George Anderson, Theophilus and Anne Andrews, Leon and Margaret E. Brown, Watson Brown, Patricia Butler, Florence Carrington, David and Mary Clark, Gladys Clark, Sidney Clark, Dorothy Copper, Olivette Davis, Dr. Patricia Debnam, Elva Jones Dulan, Sydella Edwards, Richard Fleming, Dr. Blanche Fleming, Robert and Jean Fleming, Leroy Gaines, K. Lorraine Hamilton, Tempie Harding, Pattie L. Harris, Dr. Pattie Harris, Handy Hayward, August and Katherine Hazeur, C. Wallace and Helen Hicks, Nathan "Doc" Hill, Clara Hollis, Lorin and Elizabeth Hunt, Gilbert and Ruth Jackson, Hilmar and Yvonne Jensen, Madeline Bolden Johnson, Janet and Edward Loper, Sylvia Mack, Dr. Eugene and Mildred T. McGowan, Littleton and Jane Mitchell, Pastor Aretha Morton, Reverend Maurice Moyer, Devere Patton, Samuel and Sadie Peterson, Eugene C. Petty, Bernard Pinkett, Zebulum and Katherine Ross, Marjorie Scott, Howard and Cora Toliver, Dr. Helen Turner, Barbara Washam, Eldridge Waters, Georgia Wells, Judge Leonard Williams, Dr. Woodrow Wilson, Daisey Evans Wingfield, Lisa Casson Woolford, William Young Jr., and Leonard Young Sr. The following institutions also provided assistance: the Hagley Museum and Library, the Historical Society of Delaware, the Christina Cultural Arts Center, and the Belvedere Fire Company. Gerald Piotrowski of Colorworks Photographic Services worked wonders in reproducing some of the images.

I would like to thank Shameka Snow, a student at the University of Delaware, for assisting in some of the research. Monica Williams was indispensable in assisting with compilation, organization, and general administrative tasks. She kept me organized and on track. Samantha Hollis pitched in to help me complete the manuscript. Thanks a lot.

I would also like to thank several friends who have continually provided moral support in all of my creative endeavors: Gerri Burks, Nita Benson, Clara Hollis, Deborah Morgan, Nedra Neal, Sharon Whitney, Joseph and Helen Williams and "Pops." Thanks for always being there for me. I am indeed grateful for the spiritual guidance and friendship of Cannon Lloyd Casson. He has encouraged me to take risks. I cannot forget my mentor Dr. Beryle Banfield who provides immense professional guidance. Two family members who listen patiently and lovingly even when they are tired and exhausted are my aunt Jeanne Parler and cousin James Purnell.

This book is dedicated to my father, the late Floyd J. Nutter, and my mother, Marie B. Nutter. They both provided an environment that taught me to be an independent and creative thinker. I love you both.

Introduction

African-American life in Delaware from the late 1800s to the 1960s was characterized by a struggle for equity in a time when there was none. Consequently, the community was forced to develop its own institutions and activities based on their own cultural norms. What emerged was a richness that has never been recaptured. The standards set for men, women, and especially children were high, and all were encouraged to reach their highest potential. What is apparent from the photographs is the highly structured nature of the society especially in education, religious, and social life. Individuals emerged as leaders, locally and nationally. They made extraordinary accomplishments in education, medicine, the arts, sports, religion, and the military. This small state produced or attracted the best and the brightest of African-American minds.

Early education for African Americans in Delaware was almost nonexistent. After the Civil War, the situation improved somewhat, but Delaware was the only state in the Union that had a separate system of taxation for African-American and white schools. That meant that African-American revenue went to African-American schools and white revenue went to white schools. Since most African Americans in the southern part of the state did not own sizable property, they had little to contribute in taxes. Not until industrialist and philanthropist P.S. duPont rebuilt all 89 of the African-American schools in the 1920s, did the situation improve. The school buildings may have been inadequate at first, but the teachers were highly skilled. African-American teachers during the 1920s had a higher proportion of normal school certificates than did white teachers. After the new schools were built these highly talented educators were able to use their skills more effectively. This is no more apparent than at Howard High School in Wilmington and Booker T. Washington School in Dover. Very innovative and creative activities were also happening at number 5, 20, and 29 schools in Wilmington.

Religious life was highly structured and churches created major centers of activity. Sunday schools, vacation Bible schools, women's organizations, men's organization, usher boards, choirs, and scout troops all created a synergy that drew young and old, rich and poor.

Social organizations abounded. Delaware was home to all of the major fraternities and sororities. Much of the social activity surrounded the Walnut Street YMCA. This institution was the center of African-American activity during the 1940s, 50s, and 60s. There were athletic teams, ballet classes, bowling teams, dances, mother and daughter banquets, father and son banquets, day camps, and a myriad of other programs. Everyone met at the "Y." Outside of the YMCA, there were bridge clubs, theater guilds, and other interest groups. However, one of the oldest men's clubs in the nation, the Monday Club, was started right in Wilmington.

Delaware was a state that loved sports and several individuals performed on the national level. Baseball Hall of Fame honoree Judy Johnson played for the Pittsburgh Crawfords of the Negro Leagues; Leroy "Toot" Ferrell played for the Baltimore Elite Giants with such greats as Joe Black. Billy Bruton went to the majors and played for the Milwaukee Braves. Lou Brooks, a heavyweight boxing champion, was rated seventh in the nation. Even though he did not make the majors, Handy Hayward was a local hero playing with the independent teams of the Green Dragons, the Peerless Frank Crawford All-Stars, the Wilmington Potomacs, and the Buttonwood Tigers.

During World War II, many individuals made history. Littleton P. Mitchell and Louis Purnell were part of the elite Tuskegee Airmen. Louis Purnell was a fighter pilot. Daisy Evans Wingfield was one of the first African-American army nurses. Other individuals excelled in the arts, civil rights, and the professions. This was indeed a highly productive time for African Americans.

One

FAMILY ALBUM

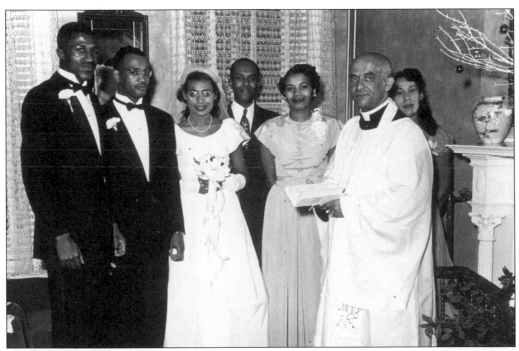

Marriage and family was always important to the African-American community, and weddings were special occasions to celebrate that fact. Here is the wedding of Howard and Muriel Cooper, both of whom were educators. Mrs. Cooper was also an artist who worked in mixed media. Those individuals who were part of the wedding party are, from left to right, Emmanuel Butler, Howard Cooper, Muriel Cooper, William Young Jr., Elaine Butler, Reverend Seymour Barker, and Dolores Frazier. The photo was taken at the home of Madeline Burton.

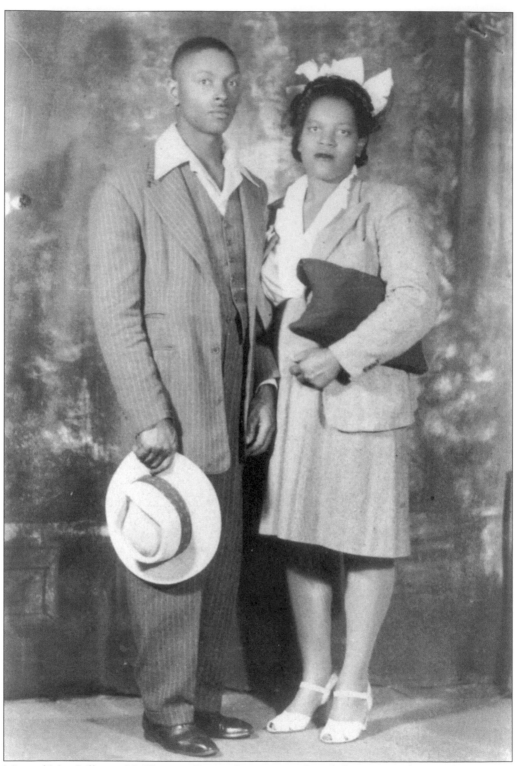

Mr. and Mrs. Jefferson H. Hayman Sr. are shown as newlyweds living in Delaware City.

Alice Anderson, holding baby Thomas, is seen here with her children, Elizabeth and Robert. Elizabeth became a teacher, Robert became a doctor, and Thomas a became a merchant marine. Alice's husband, Thomas Anderson, was a teacher at Howard High School.

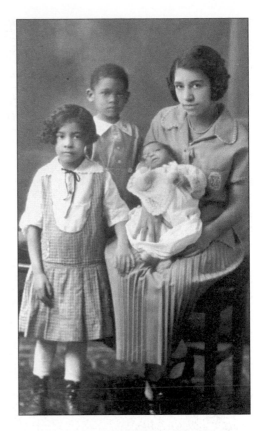

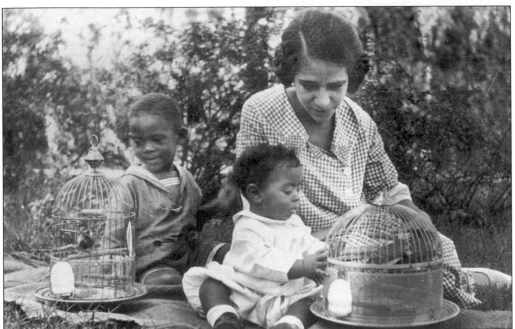

In this c. 1920s image, Alice Anderson sits with sons Thomas and Robert as they play with their pet parakeets.

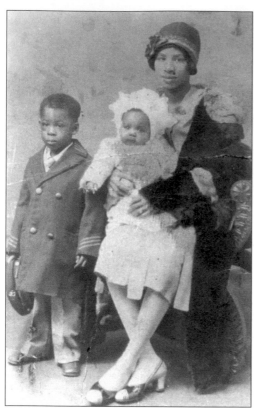

Jenny Ambrose poses with son Gilbert Jackson and baby Jenny (a niece) on her lap.

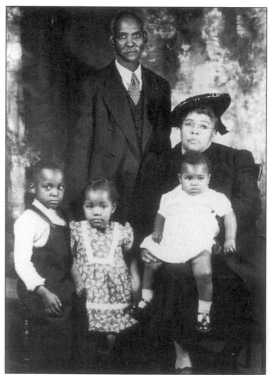

Mary Pinkett Fullman and her husband, Harry Fullman, pose in the 1940s with their children, who are, from left to right, Jerome Pinkett, Mary Pinkett, and baby Mildred Pinkett.

One Sunday afternoon, Littleton P.
Mitchell (left) and friends Charles Walls
and David Parker (right) posed in their
knickers and sailor suits.

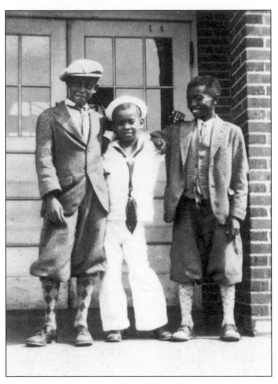

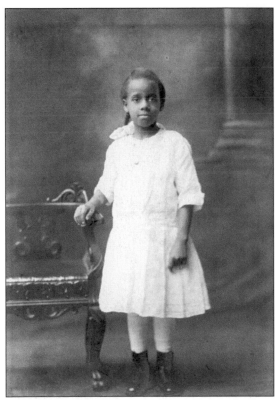

Madeline Burton is the perfect young
lady in her white dress and high-
buttoned shoes.

13

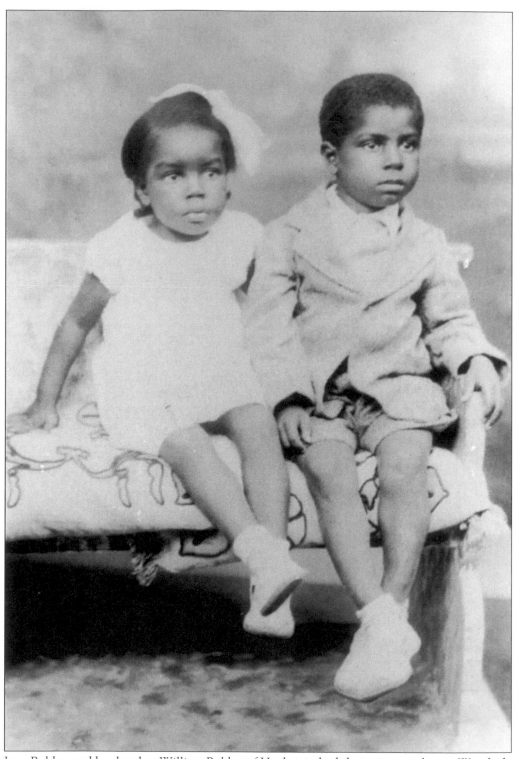

Jean Bolden and her brother William Bolden of Hockessin had their picture taken at Woodside Park in Philadelphia, c. 1937.

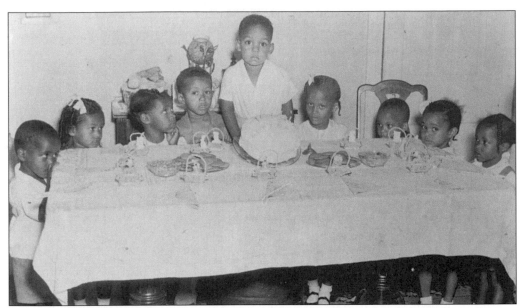

Robert Davis Jr. and friends celebrate at his third birthday party.

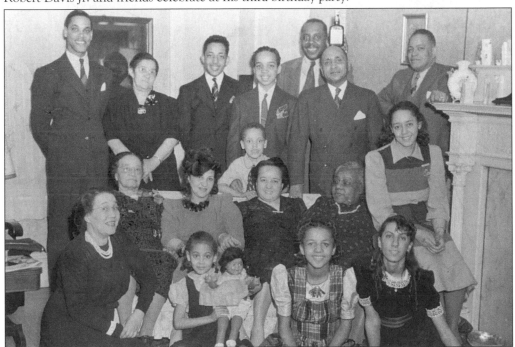

Mom Chase's birthday party was an enjoyable event for young and old alike. Two gentlemen in the picture were highly successful and influential people in the African-American community. They were (last row, first two men on the right) John O. Hopkins and A. Roland Milburn. Hopkins was a city councilman in Wilmington for 32 years, a member of the Republican State Committee, and a businessman who owned and operated a well-known movie theater. Milburn was a pharmacist and, during the 1940s, the only African-American City Committee treasurer in the United States (according to a GOP publication). Notice the African-American doll the little girl is holding.

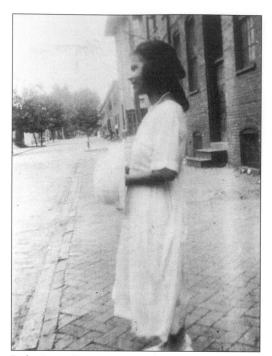

Left: Anna Benson is seen here as a young woman. *Right:* This beautiful woman is unknown.

Jenny Ambrose is pictured here about 25 years before she owned and operated her own store—Jenny's Gift and Card Shop at Eighth and Walnut Streets.

Two
EDUCATION

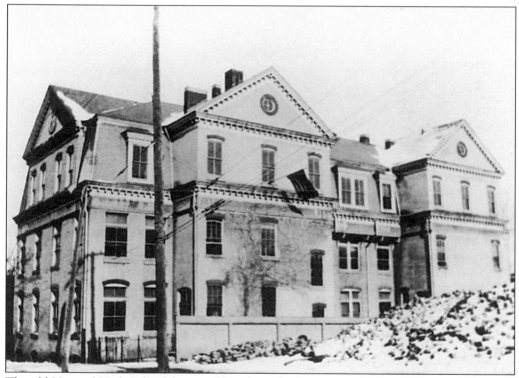

The old Howard High School (pictured here) was built in 1869 and used until 1928, when the new Howard High School was built. This institution was the only high school for African Americans in the entire state until the 1920s. As a result, many African Americans were denied a high school education because of their inability to travel to or board in Wilmington. Those who had the opportunity received an excellent education with highly trained teachers and a well-grounded curriculum.(Courtesy of the Historical Society of Delaware.)

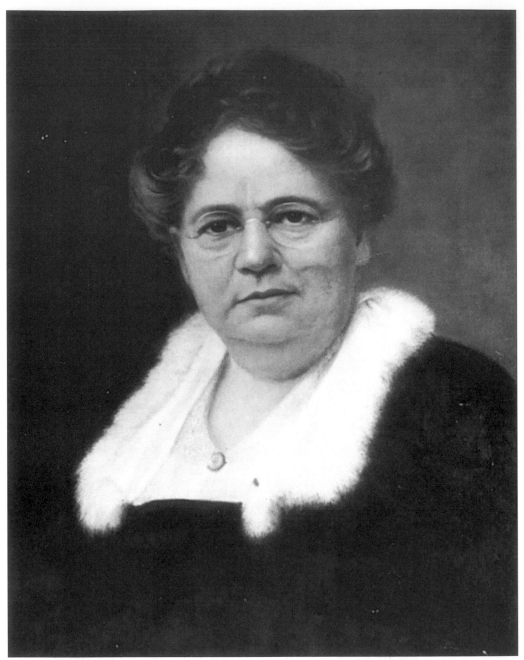

Edwina B. Kruse was the first African-American principal of Howard High School. Her administration covered a span from 1876 to 1920. During that time, Howard included grades kindergarten through 12. Considered one of the foremost educators of African-American children, Kruse exposed the students to such visitors as Frederick Douglass, Paul Laurence Dunbar, Mary Church Terrell, and W.E.B. Du Bois. At one time she was principal of both Howard High School and School No. 29. In addition to her educational activities, she helped found Gilbert Presbyterian Church. (Courtesy of the Historical Society of Delaware.)

In this picture of a Howard High School class, the famous Alice Dunbar Nelson is the teacher seated on the right. She was the head of the English Department of Howard from 1902 to 1920. She was editor of the *Advocate*, the *A.M.E. Church Review*, and also wrote the book *Dunbar Speaks*. Alice Dunbar Nelson was an activist for social justice.

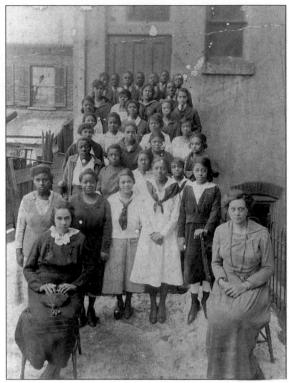

Pictured here is the niece of Alice Dunbar Nelson, Pauline Young. She later became the librarian of Howard High School from 1919 to 1955 and wrote extensively on the history of African Americans in Delaware. Young served as the president of the Wilmington chapter of the NAACP. A daring woman, she attended the 1936 Olympics in Berlin despite government warnings about such a visit.

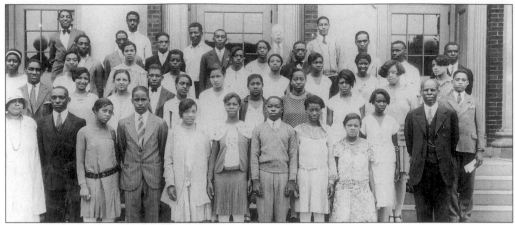

This is the first graduating class (1929) of the new Howard High School built by P.S. duPont at a cost of close to $1 million. Pictured here, from left to right, are (front row) Anna G. Broadnax, James White, Sadie Johnson, Clerence Burton, Elizabeth Bungy, Blanch Richardson, Lorenzo Morris, Henrietta Boyer, Georgia James, and George A. Johnson (principal); (second row) Paul Taylor, Vivian Simpers, Margie Hopkins, Vernell Brown, Watson Brown, Daisy Lowery, Catherine Johnson, Laura Toliver, Anna King, Hope Benson, and Winder Porter; (third row) Geraldine Wilson, Mary Christian, Marion Jones, Ruth Bird, Evelyn Moore, Roberta Maul, Odessa Stafford, Anna Hackett, and Verda Mae Freeman; (fourth row) Hollis Tildon, Louis Waters, Clarence Hutt, Roland Butler, Pearline Tildon, Samuel Peterson, Donald Thompson, Walter Fleming, and Thomas Jenkins; (back row) Bernard Saunders, Brice Miles, Enoch Hayward, Ralph Carty, and Stanley Wingfield.

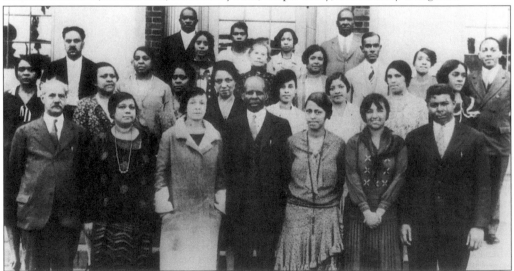

This 1930s picture shows the faculty standing before the new Howard High School. From left to right are (front row) Robert L. Harris, Anna F. Broadnax, Helen Anderson, George A. Johnson (principal), Pauline A. Young, Sarah Strickland, and Millard Naylor; (second row) Ethel Harris, Charlotte Slowe, Caroline R. Williams, Nellie B. Taylor, Sadie L. Jones, Thelma T. Young, Arlene Bowser, and C. Gwendolyn Redding; (third row)Arthur Wheeler, Josephine Weston, Marguerite Turner, M. Leila Young, Etta Woodlen, James A. Gardiner, Lillian Mayo, and G. Oscar Carrington; (back row) Emanuel Whitten, Pauline E. Coleman, Natalie A. Cross, and George T. Whitten.

Many Howard High School teachers were well traveled, such as Arlean Bowser, a French teacher, who is pictured in front of the Coliseum in Rome, c. 1930s.

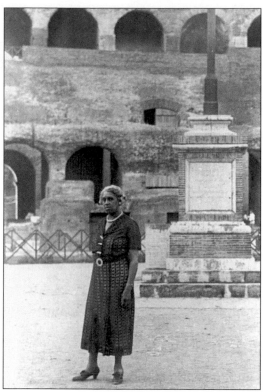

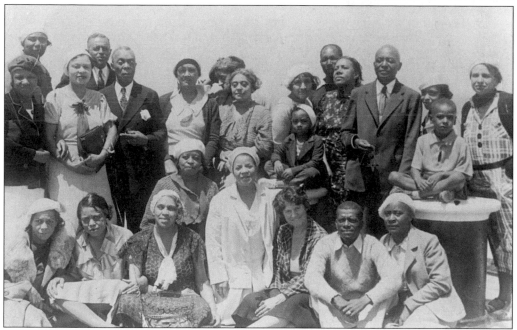

Bowser and her colleague Caroline Williams are picture here on the Ile de France on July 29, 1935. Williams is the first woman on the right in the first row, and Bowser is the third from the left on the first row. Mr. Hodge, poet Countee Cullen's father, is the gentleman standing with the white pocket handkerchief.

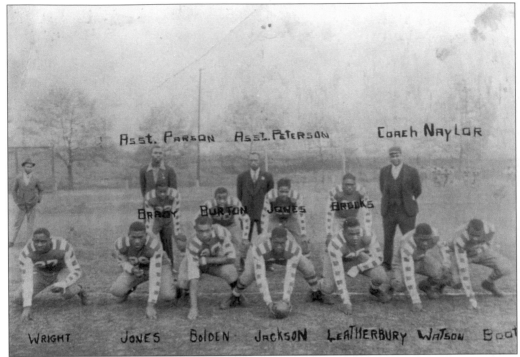

In this 1938 picture of the Howard High School football team, the famous coach Millard Naylor is standing in the back row on the right. He was Howard High's first coach and continued his career there until 1957.

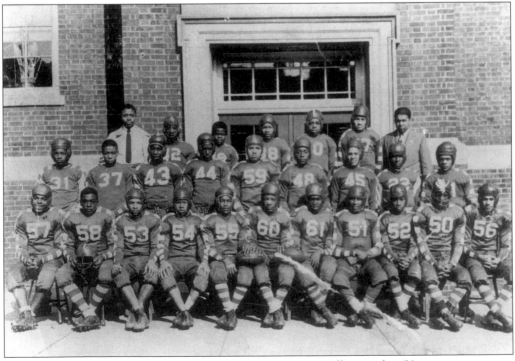

This is a 1940s picture of the football team. Nathan "Doc" Hill is number 50.

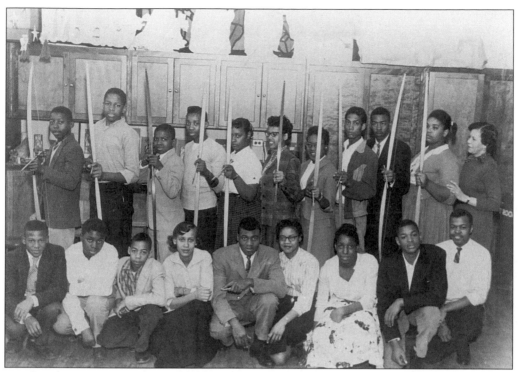

Rosalia Mabry O'Neal is pictured here with her archery class.

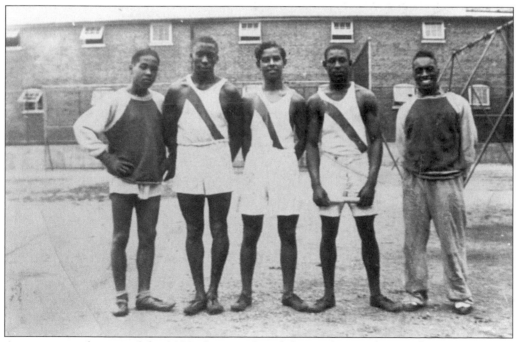

A winning track team of the 1930s features, from left to right, Wesley Smith, Howard "Key" Toliver, Saint Julian De Costa, Gilbert "Slew" Jackson, and ? Baylor.

Marion Anderson performed at Howard High School in the late 1940s. From left to right are Nellie Taylor, George A. Johnson, Marion Anderson, Rosie O'Neal, and Gwendolyn Redding.

Howard High School produced its own classical singers, and Madeline Bolden was selected to sing for Eleanor Roosevelt when she visited Wilmington in the early 1950s.

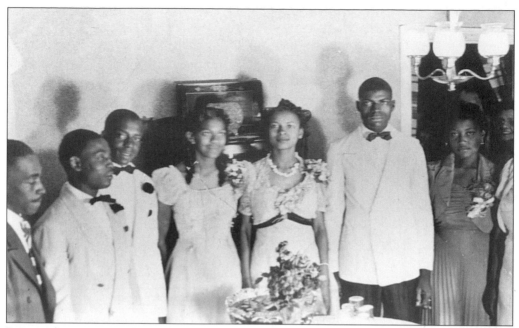

Prom night was a special event in the 1940s. Here, several young people are leaving to go to the Howard High prom. From left to right are ? Jones, Gilbert Jackson, William Jackson, Alveta Hudson, Mary Quarles, Sonny Braxton, Florence Turner, Mrs. Hudson, and Melissa Toliver (partially obscured).

This beautiful young woman is Jane Watson at her senior prom. The beautiful bouquet is from her date, Littleton P. Mitchell, who eventually became her husband. Jane Mitchell was the first African-American nurse to take care of both African-American and white patients in a hospital facility. Much later she was appointed as the first African-American director of nursing at the Delaware State Hospital.

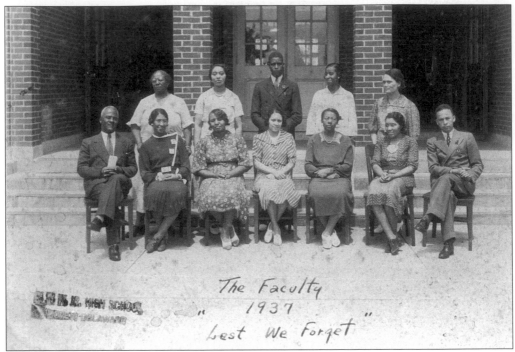

The faculty of the Booker T. Washington School in Dover is seated in front of the school. The gentleman seated in the first chair on the left is the famous principal S. Marcellus Blackburn. The faculty are, from left to right, (first row) Adalyn Brown, Lillian S. Sockam, Mrs. Farrar, Carrie Blackson, Myra Webster Gibbs, and William J. Laws; (back row) Vivian Anderson, Mary Christian Floyd, James C. Hardcastle, Marjorie Fisher, and Flossie Buckner.

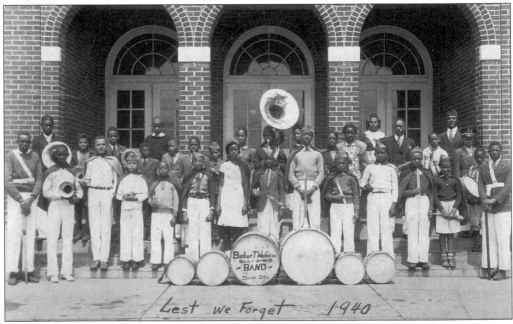

S. Marcellus Blackburn, the principal of the Booker T. Washington school, loved music. It is no wonder that the school had such an impressive band.

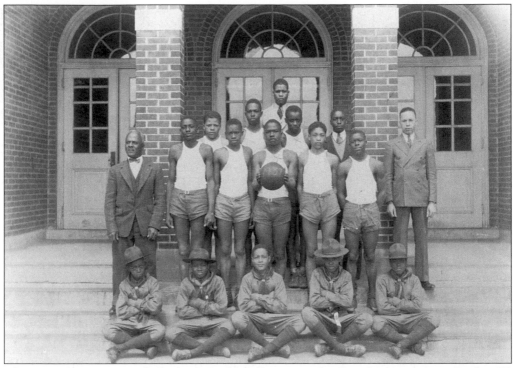

This is a 1936 picture of the boy's basketball team and a Boy Scout troop at Booker T. Washington School. Standing is the principal S. Marcellus Blackburn and teacher William J. Laws.

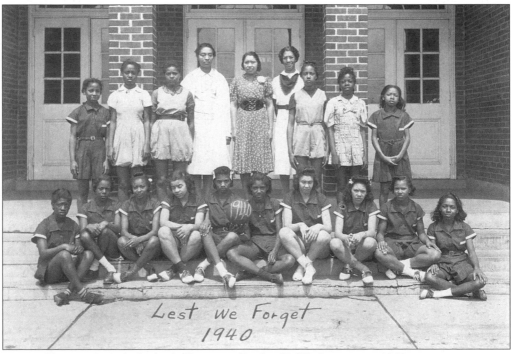

Pictured here is the girl's basketball team at Booker T. Washington in 1940.

These are pictures of a night school class in Wilmington in the 1930s.

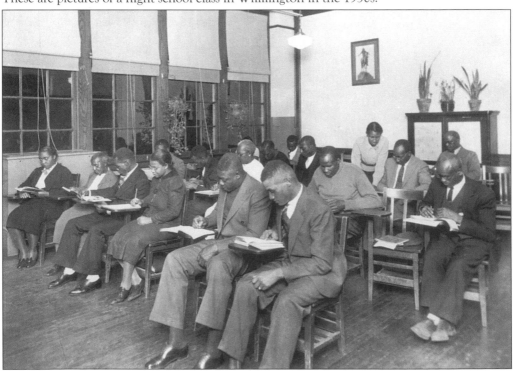

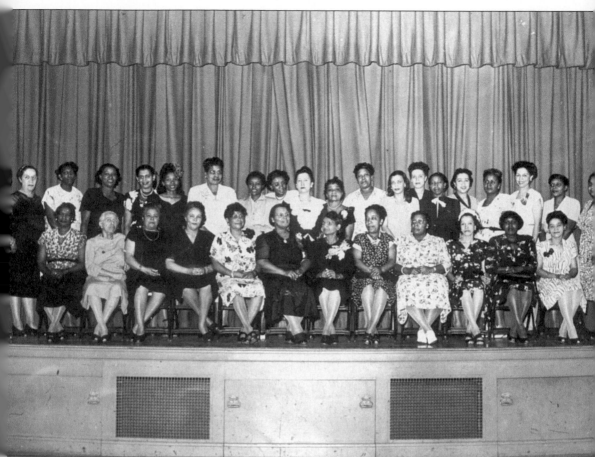

This is a picture of the combined faculties of school No. 5, No. 20, and No. 29. They are, from left to right, (front row) Mahalia Turner, Sylvia Carty, Etta Woodlin, Courtly Adams, Gertrude Henry, Carrie Wiggins, Sophia Edwards (principal), Beatrice Lewis, Mary Foreman, Hazel Johnson, unidentified, and Anna Comegeys; (back row) Lillian Spencer, Elsie Bryant, Sara Wright, Rosa Bridges, Katherine Young, Venus Johnson, Lucy Toliver, Henrietta Henry, K. Lorraine Hamilton, Annie Marks, ? Coleman, Carrie Wicks, Louise Brinkley, Edith Barton, Martha Evans, Maude Smith, Lillian Redding, Miriam Bridge, Lillian Turner, and Helen Mosley.

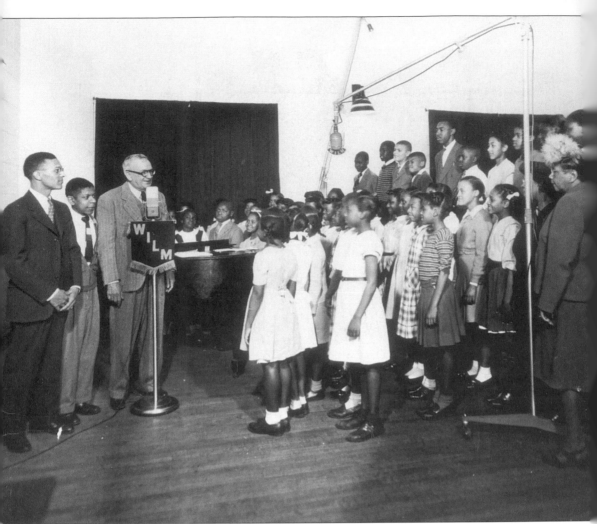

This is a 1948 picture of the combined chorus of public school No. 5, No. 20, and No. 29 at Station WILM Radio. Eldridge Waters was the principal for all three schools. Pictured on the far left is chorus director David Closson. The students who participated in the program were Ernestine Dorsey, Pattie Harris, Roberta Smith, Katherine Butler, Mary McCain, Carolyn Bailey, Christine Taylor, Lucy McCall, Louise Carter, Merle Anderson, Madeline Bolden, Ernestine Woodward, Edith Faulke, Edna Waters, Jacqueline Dorsey, Alice Faulkner, Portia Milbourne, Bernice Morris, John Gray, Carl Shavers, Warren Blackson, Richard White, Carrie Simpers, Audrey Harris, Jacqueline Smith, Shirley Robbins, Dorothy Davis, Willamae Connor, Shirley Harris, Louella Macklin, Jacqueline Dickerson, Roberta Sommerville, Barbara McIntosh, Yvonne Robinson, Sherman Money, John Morton, and Frank Gordon.

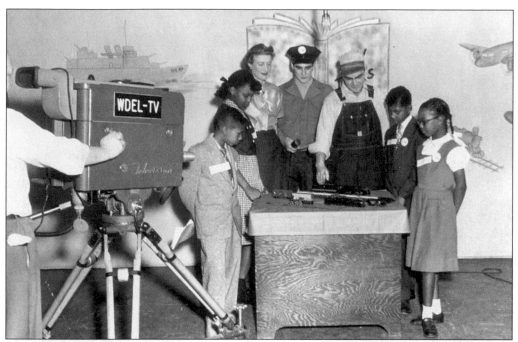

These students from No. 29 School appear on television station WDEL-TV in the 1940s.

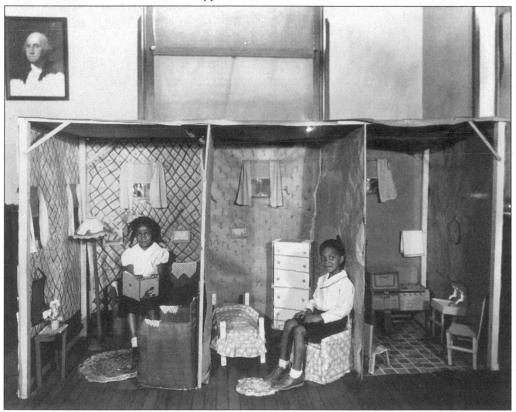

Anna Comegeys's first-grade class at No. 5 School worked on this project in the 1940s.

Pictured here in the 1950s is Katherine Hazeur, one of the youngest African-American principals in the Wilmington system at the time.

Eldridge Waters was the first African-American male elementary school principal in Wilmington. He managed the No. 5, 20, and 29 Schools, supervising 1,000 pupils in the 1940s . In the early 1950s, he became the principal of the new Stubbs School.

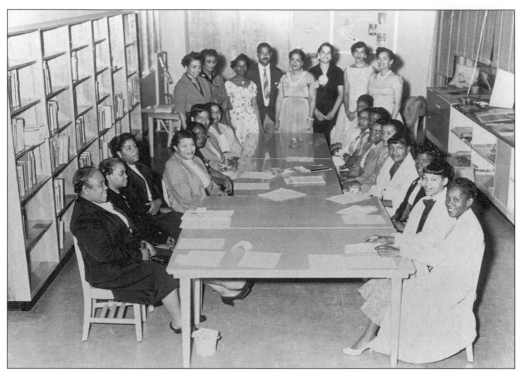

This is a 1950s photo of the first Parent-Teacher Association at Stubbs Elementary School located on the east side of Wilmington. Stubbs School was named after a prominent African-American physician.

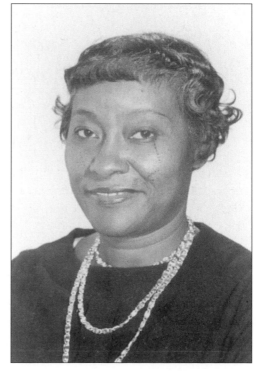

Henrietta B. Henry was a teacher at the Stubbs School in the 1950s but left in the 1960s to become the first African-American member of the professional staff of the Wilmington Public School Administration.

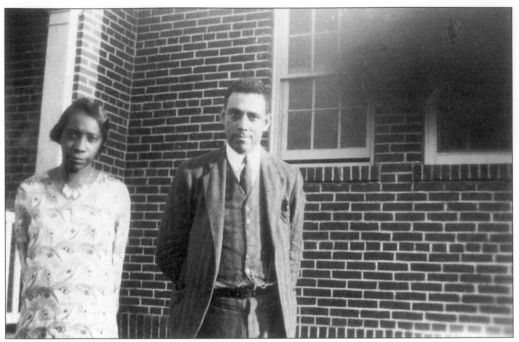

Pictured here are Bertha Battle and Albion Unthank, teachers at the Booker T. Washington School in New Castle.

Gladys Green was a student of Ms. Battle and Mr. Unthank and became the first female city council member in the City of New Castle.

Sylvester Woolford and James Colburne were both teachers and principals of the Buttonwood School. Colburne was noted for his musical talents.

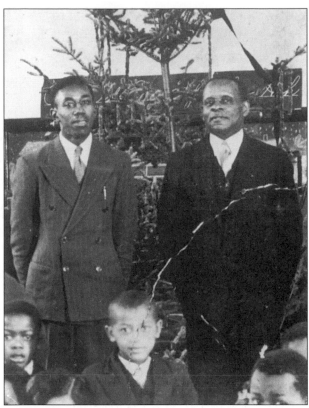

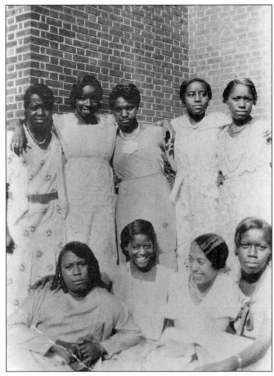

One of the students of the Buttonwood School who graduated and went on to Howard High School in the 1930s was Leona Black. She is standing (third from left) with some of her friends.

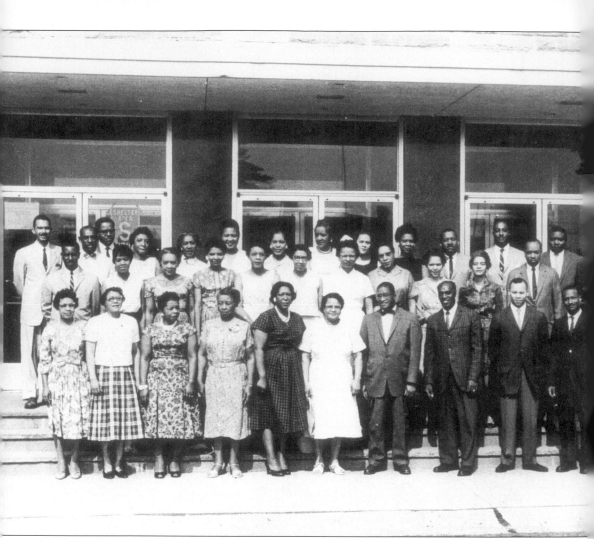

This is the Dunleith School faculty. This school served the Dunleith community, which was the first planned suburban community for African Americans in the state of Delaware and was constructed in the early 1950s. The school was built later. The faculty are, from left to right, (front row) Ruth Brown, Menthal Brewington, Mrs. Cane, Ethel Jackson, Bernice Horner, Marian Beaujohn, Earl Brown (principal), Ben Rogers (assistant principal), Frank Purcell, and Robert Shipley; (second row) Raymond Woodard, Ruth Neal, Eleanor Tiggs, Lilian Benson Quarles, Marjorie Mulligan Priest, Erma Boyer, Mary Q. Brown, Edith Pridgeon, Harriet Seldon, Elizabeth Hunt, and Victor Smith; (back row) Hilmar Jensen, Gilbert Jackson, James Hayes, Gloria Wilson, Margaret West, unidentified, Litilia Braxton, Patrick Walker, ? Threadgill, and William Carr.

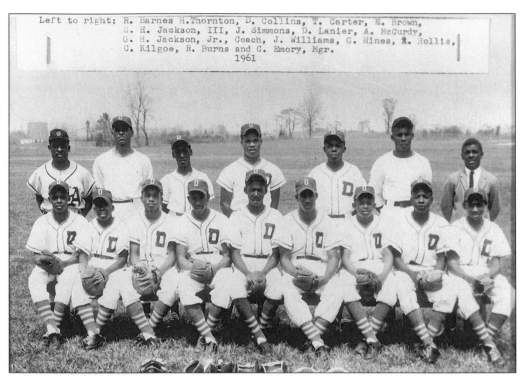

Left to right: R. Barnes H.Thornton; D. Collins, T. Carter, E. Brown,
G. H. Jackson, III, J. Simmons, D. Lanier, A. McCurdy,
G. H. Jackson, Jr., Coach, J. Williams, C. Hines, R. Hollis,
C. Kilgoe, R. Burns and C. Emory, Mgr.
1961

This is a Dunleith School boy's baseball team with their coach Gilbert Jackson, who is wearing a baseball uniform given to him by Judy Johnson, a player in the Negro leagues.

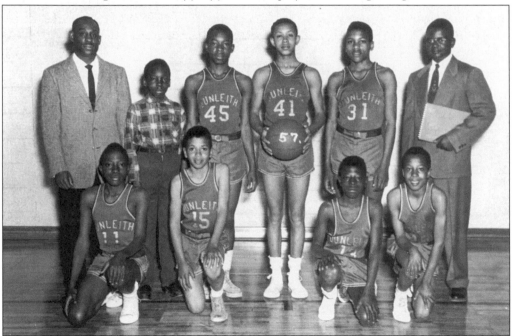

This is a Dunleith basketball team in the 1960s. The manager, Thomas Jenkins (standing far right), eventually left sports to become a dentist. Coach Gilbert Jackson is standing on the far left.

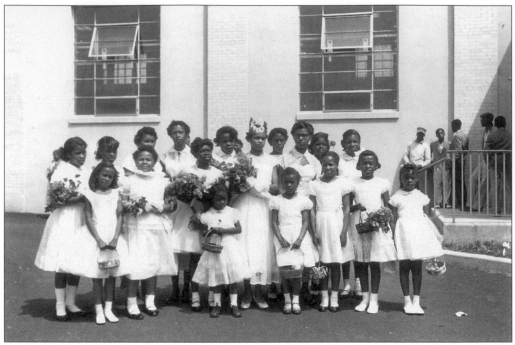

Pictured here is a 1960s May Day court at the Absalom Jones School.

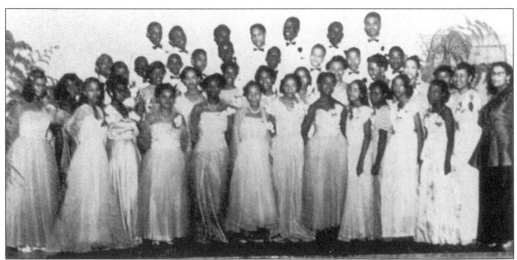

The co-ed Glee Club of the Absalom Jones School under the direction of Katherine B. Ross and Zebulum J. Ross became renowned for their renditions of both classical music and spirituals. Doris Camper (far left), an excellent singer, was chosen to be a soloist at the first integrated summer music camp for high school students held at Wesley College.

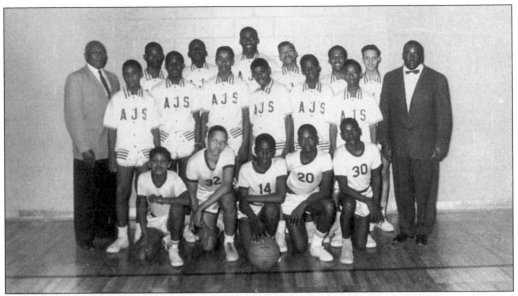

The Absalom Jones basketball team is pictured with principal John A. Taliaferro, left, and coach Howard K. Toliver, right. The team members are, from left to right, (front row) Thomas Hairston, Billy Harmon, unidentified, James Roberts, and Franklin Davis; (second row) Emory Woodard, unidentified, Ernie Anderson, Ronnie Anderson, Alvin Wiggins, and Reggie Hayward; (back row) Eugene Calloway, Maynard Scales, Robert Spurlock, Pinkney Smith, Leon Price, and Kendall Gardner.

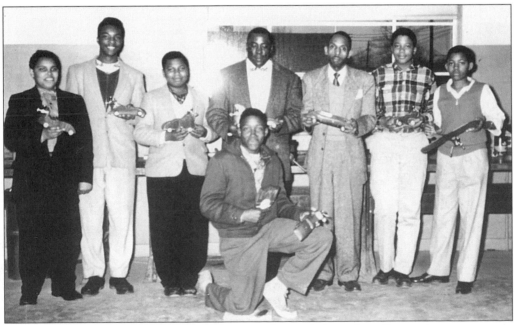

Teachers Howard Toliver and Floyd Nutter understood the value of nurturing young men. They organized miniature auto clubs and airplane clubs for the adolescent boys. Pictured here are, from left to right, James Church, unidentified, Richard Pyle, Howard Toliver, Floyd Nutter, Ulysses Smith, and unidentified. James Saunders is kneeling.

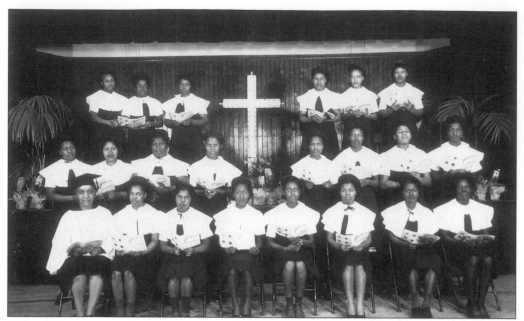

Helen Turner, principal of the Academic School at the Girls Industrial School, is seated with the young women she conducted in the choir. The program for young women was so comprehensive the students fondly called it a "finishing school for young ladies."

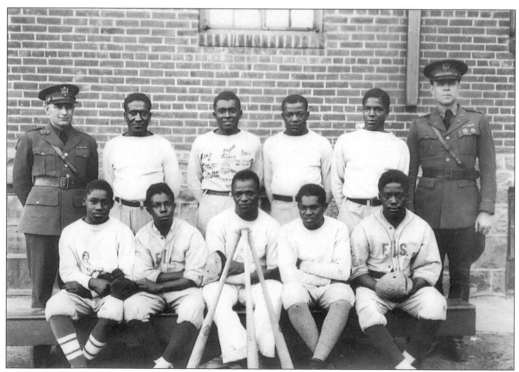

A baseball team of the Ferris School for boys is pictured here. (Courtesy of the Historical Society of Delaware.)

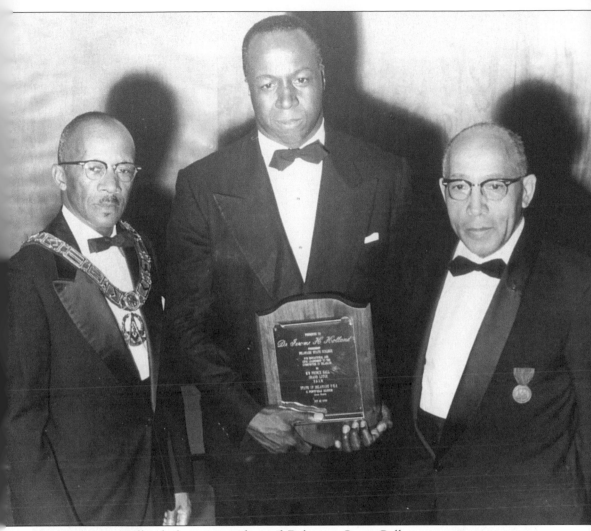

Dr. Jerome H. Holland, former president of Delaware State College, is seen receiving an award from the Masons. On the left is C. Portfield Harris, grand master, and on the right is G. Oscar Carrington. Dr. Holland eventually left Delaware State and was appointed ambassador to Sweden.

This is a picture of the Home Economics Department of Delaware State College during the 1940s. The faculty member on the left is Nannie Waters, and the faculty member on the right is Ruth Laws. Dr. Laws later distinguished herself as an outstanding educational leader in the field of Home Economics.

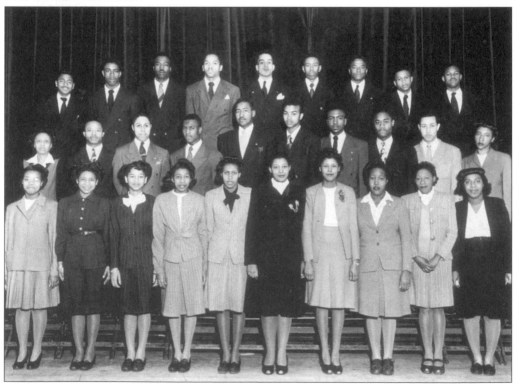

This is a 1940s picture of the Delaware State Choir.

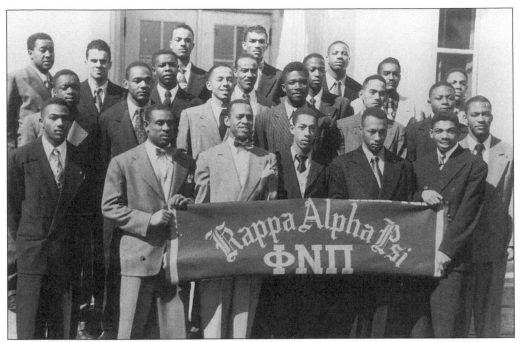

Pictured here are the members of Kappa Alpha Psi Fraternity in 1947.

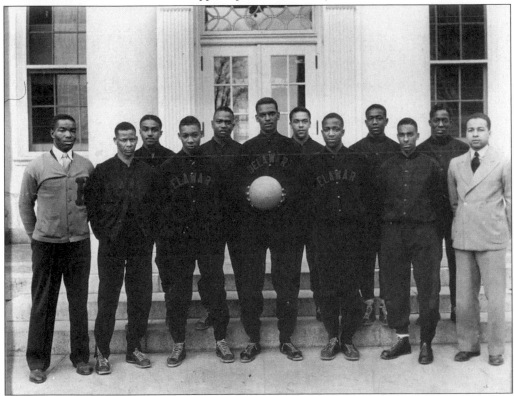

This is one of the Delaware State College basketball teams. The young man holding the basketball is Willis Powell, who later became a school principal.

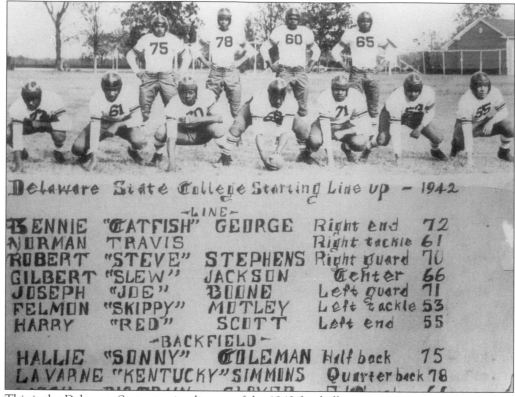

Delaware State College Starting Line Up – 1942

-LINE-

BENNIE	"CATFISH"	GEORGE	Right end	72
NORMAN	TRAVIS		Right tackle	61
ROBERT	"STEVE"	STEPHENS	Right guard	70
GILBERT	"SLEW"	JACKSON	Center	66
JOSEPH	"JOE"	BOONE	Left guard	71
FELMON	"SKIPPY"	MOTLEY	Left tackle	53
HARRY	"RED"	SCOTT	Left end	55

-BACKFIELD-

| HALLIE | "SONNY" | COLEMAN | Half back | 75 |
| LAVARNE | "KENTUCKY" | SIMMONS | Quarter back | 78 |

This is the Delaware State starting line up of the 1942 football team.

Margaret Roberts was well known for her outstanding twirling and the eye-catching splits she performed as she led the band at Delaware State College.

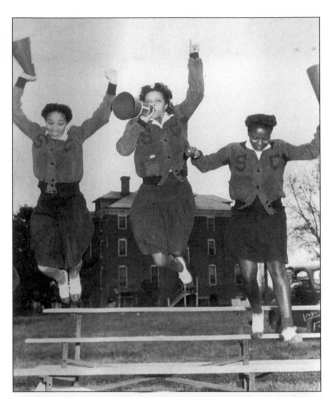

The cheerleaders led the men to victory on the field and on the court. Pictured, from left to right, are Ruth Thomas, Sarah Berry, and Ida Baynard.

Women also participated in sports activities at Delaware State. Seated here is the women's basketball team in the 1940s. Ruth Thomas, standing at left, was the coach.

Ethel Jackson is seen here as she graduated from Delaware State in 1927. She began her teaching career in the lower part of the state but eventually moved to Wilmington and taught at the Dunleith School.

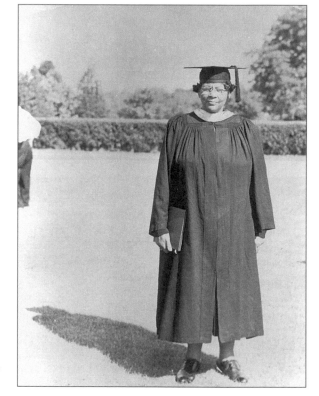

When Lucy Toliver got her first degree it was a Normal School certificate. This was the case for most of the teachers of her age. In the 1950s, she returned to school for a bachelor of arts degree from Delaware State College.

Three
RELIGIOUS LIFE

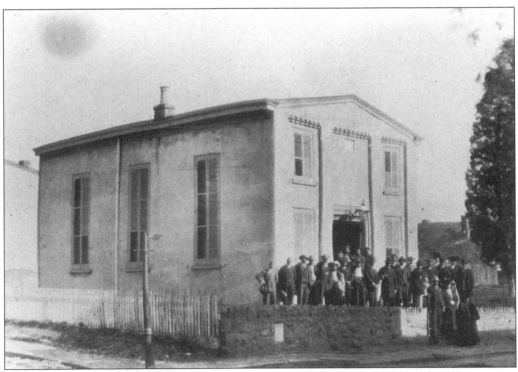

Peter Spencer organized the Bethany UAME Church of New Castle in 1815. Here is the congregation at about the turn of the century.

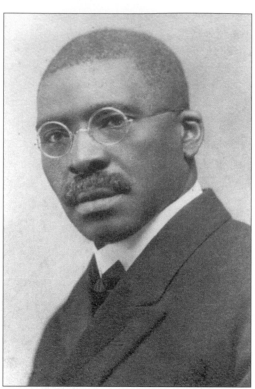

Reverend Raymond Brown was the pastor of Ezion Methodist Church in the late 1920s.

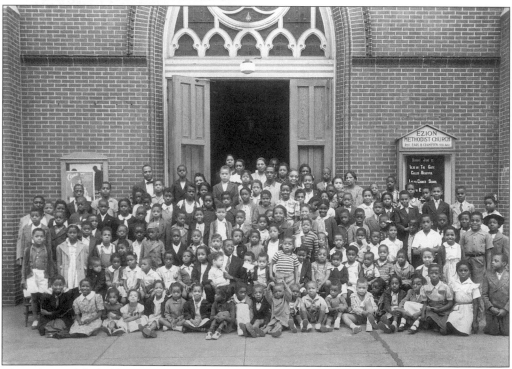

These beautiful children are part of the vacation Bible school held at Ezion Church in the 1940s.

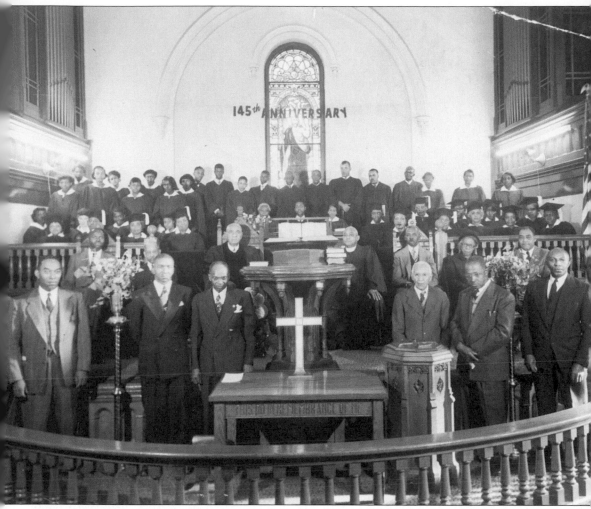

Here, the leaders of Ezion Church are celebrating their 145th anniversary. The minister, Reverend Spence, is seated on the right.

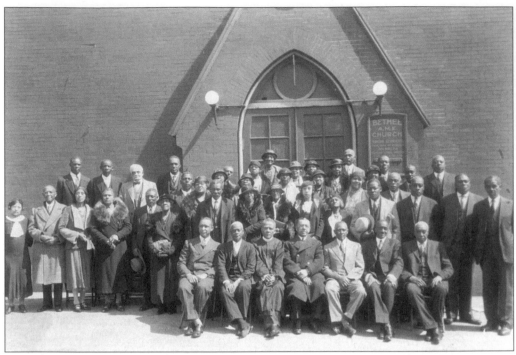

This is a 1930s picture of Bethel AME Church, which was organized in 1846.

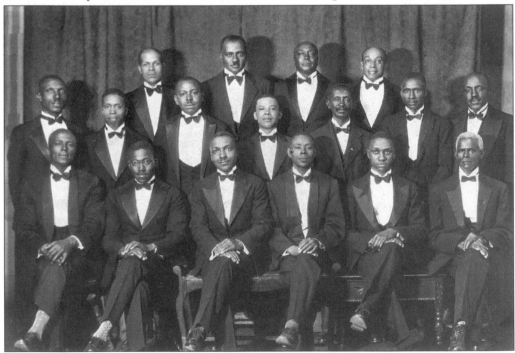

The gentlemen seated here are members of the Bethel Church male chorus. William H. Brown, the conductor of the chorus, is seated third from the right. Maynard Messick, the organist, is to Brown's right. To Brown's left is Edward Bell, who became one the most prosperous funeral directors in the state.

The following, pictured from left to right, are the members of the 1939 Delaware State Baptist Convention: William Pritchett (corresponding secretary); Reverend ? Price (Eighth Street Baptist Church, secretary); Reverend Arthur James (Shiloh Baptist Church); Mrs. ? Gordy (president of missions); and Harvey King.

Reverend B.T. Moore was one of the early ministers of Shiloh Baptist Church.

Assembled here is the board of the Shiloh Baptist Church. From left to right, they are (front row) Gertrude Marshall, Reverend Percy Lipscomb, and Caroline Betsy Williams; (back row) unidentified, unidentified, Leonard Gaines, William S. Young Sr., Chester Deshields, William Parks, and James Baynum.

St. Matthew's Episcopal Church was the only Episcopal church in the state. Here is the 1910 Sunday school, and the woman in the picture is a young Alice Dunbar Nelson. The minister, standing to Nelson's left, is Reverend Doty. In the first row, second from the left, is K. Lorraine Hamilton; in the second row, fourth from the left, is Pauline Young; in the third row, fourth girl from the left is Natalie Cross.

These are members of the Episcopal Church Women at Saint Matthews Church in the 1940s.

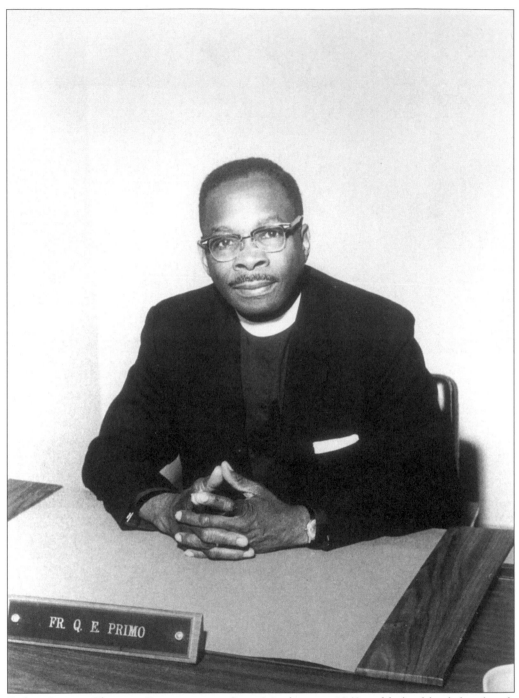

FR. Q. E. PRIMO

Father Quintin Ebenezer Primo came to Saint Matthews in 1963 and helped lead the church from mission to parish status during his tenure. He later became the first African-American bishop suffragan of the Chicago diocese.

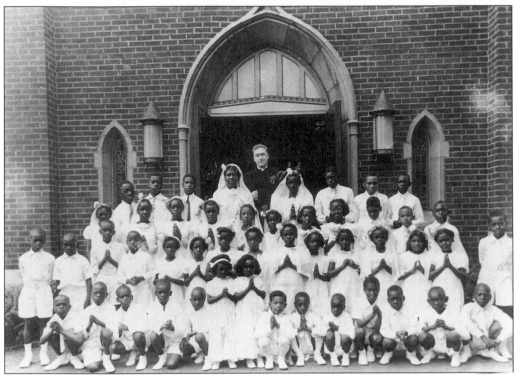

St. Joseph's Roman Catholic Church was the center of African-American Catholicism. Founded in 1889, the Church began the first orphanage for young, African-American men in the United States. Here is a first communion class. One of these young people, Leroy Gaines (last row, third from the right), eventually joined his father's business in the barbering trade.

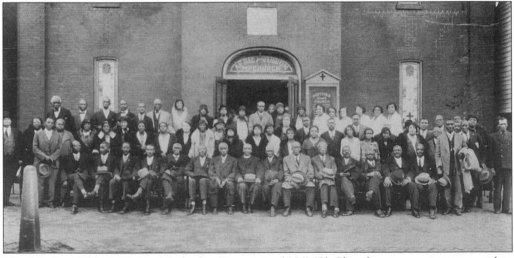

The Mother African Union Methodist Protestant (AUMP) Church congregation is seated in front of its building. It was this Church, founded by Peter Spencer, that began the African-American religious celebration called "August Quarterly." This was an African-American religious celebration that began in 1814 and incorporated preaching and singing. It was a religious reunion that brought people from near and far. Still celebrated today, it is the oldest continuous African-American folk festival in the nation.

This is a picture of the Buttonwood Church congregation at the dedication of their new church building.

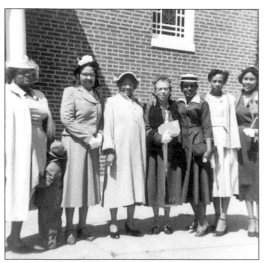

Left: The women of St. Paul's United Methodist Church of Milford are pictured here. From left to right are Sally Bell, Vivian Young, Helen Mitchell, Virginia Curry, Jane Mitchell, and Virginia Lofland. *Right:* The children of St. Paul's Church are gathered after Sunday school. They are, from left to right, "Baby" Novella, Charles Wicks, Freddy Duffy, Billy Duffy, Joan Clark, James Harris, Libby Ann Shockley, and Wanda Young.

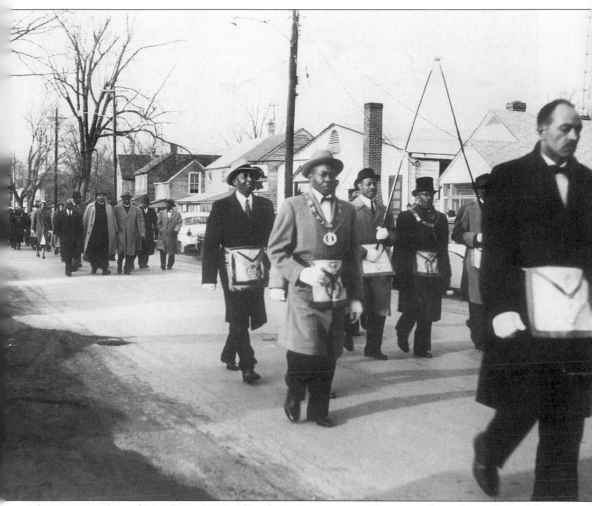

The congregation of Mt. Zion AME Church in Dover is seen here marching from their old church to their new church on September 27, 1959.

C. Wallace Hicks was the superintendent of the Sunday school for Mt. Zion for 25 years. During that time the average attendance was approximately 100 children every Sunday.

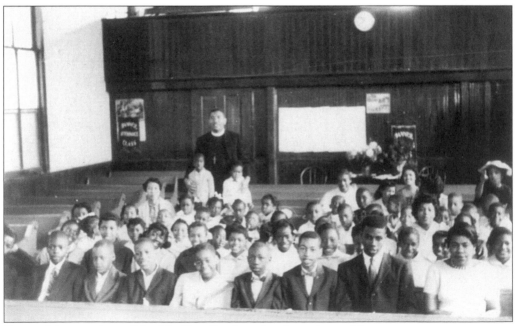

Some of the members of the Mt. Zion Sunday school are pictured here.

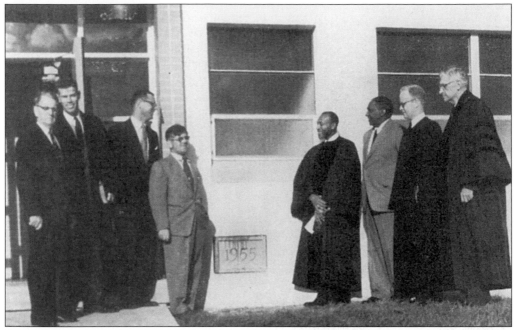

Participants in the 1955 cornerstone-laying ceremony of Community Presbyterian Church are Reverend Maurice J. Moyer, pastor (fourth from right), and Dr. Wayman Coston, trustee (third from right).

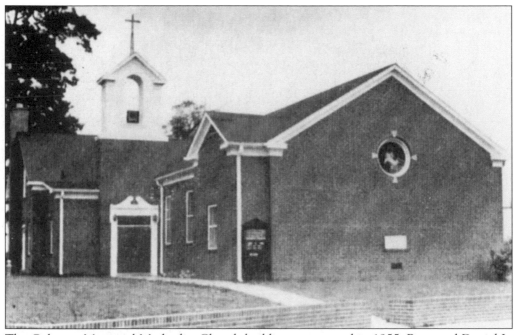

The Coleman Memorial Methodist Church building was erected in 1955. Reverend Daniel L. Williams was the minister.

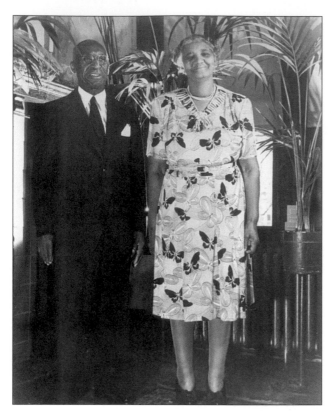

Reverend Robert Wesley Thomas was ordained as a Methodist minister in 1910. He was a supply minister from 1910 to 1923. From 1924 to 1950, he served in churches in Bridgeville, Lewes, Nassau, and other locales in the Delaware Conference.

In 1959, Pastor Aretha Morton was the first woman in Delaware licensed to preach in the Baptist Church.

Four
CIVIL RIGHTS

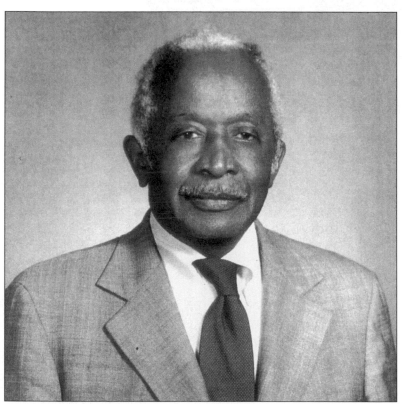

Louis L. Redding is considered the champion of civil rights in Delaware. The first African American admitted to the bar in the state of Delaware, he is best remembered for his role in desegregating the public schools. In 1952, he represented parents of African-American children in the Hockessin and Claymont school districts resulting in the Court of Chancery ruling that the students be admitted to the all-white schools. This case, *Gebhardt v. Belton*, eventually became part of the landmark *Brown v. Board of Education of Topeka*, which ended school segregation in the United States.

Here Littleton P. Mitchell is receiving an NAACP award from Roy Wilkins on behalf of his wife, Jane. She won the award for her outstanding role in the group's membership drive; she secured 250 new members. Littleton Mitchell was the president of the state chapter of the NAACP for 30 years beginning in 1961. During that time he led the fight for equal accommodations, fair housing, jobs, and migrant labor laws.

The NAACP gave awards to individuals who excelled in their membership drives. This 1940s picture shows Dr. Leon Anderson and Jane Mitchell with the president of the Wilmington chapter, Wagner Jackson.

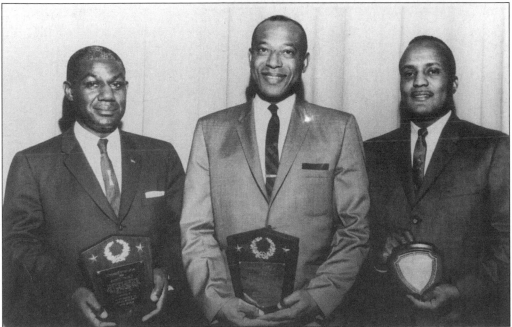

Roosevelt Franklin, left, and Reverend Maurice J. Moyer, center, are pictured with Theodore Moses as they receive the 1962 Omega Psi Phi Citizen's Award. Both Franklin and Reverend Moyer served as the Wilmington chapter president of the NAACP. Reverend Moyer's presidency ran from 1960 to 1964, during which time he successfully led the fight for jobs for African Americans as bus drivers and sales clerks in the major department stores, as well as addressing issues related to public accommodations and housing.

Luther J. Porter started working with the NAACP as a young man and served as the treasurer for most of his adult life. He is recognized as a true foot soldier in the battle for equal rights in Delaware.

Women such as Pauline Young and Alice Dunbar Nelson served in leadership roles in the NAACP, but some women, such as the ones pictured here in 1934, played other roles in maintaining the financial stability of the organization. They organized fund-raisers, such as the annual dance held at the National Theater. These women were prominent in the Wilmington community. Pictured, from left to right, are (front row) Marian ? , unidentified, unidentified, Ruth Jackson, Dolores Baker, Virginia Holmes, and unidentified; (back row) Marjorie Wright, unidentified, Mrs. ? Ayres, Helen Dickerson, ? Jones, Gertrude Henry, Dorothea Harris, Edith Barton, and Jean Jamison.

Five
SOCIAL LIFE

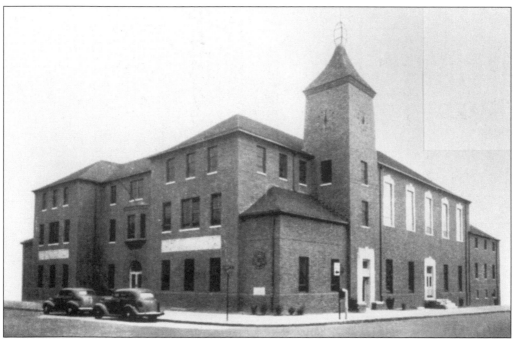

The Walnut Street Young Men's and Young Women's Christian Association held its cornerstone ceremony on November 19, 1939. From that time through the 1960s, the association was the center of African-American activity.

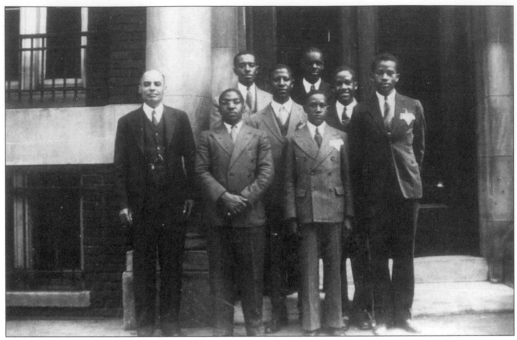

Pictured here are the Hi-Y officers of the Walnut Street "Y" in the 1930s. From left to right are (front row) Boyd Overton, the first executive director; ? Priest; ? Petty; and Conwell Pritchett; (second row) ? Chippey and ? Petty; (third row) William Young Jr. and Reginald Bruce.

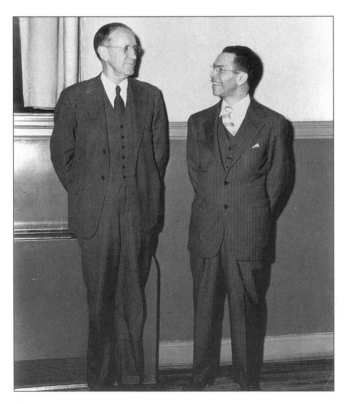

Hilmar L. Jensen (right), the director of the Walnut Street YMCA from 1949 to 1954, is pictured with ? Cook (left), the general secretary of the Central YMCA. Jensen was a member of the NAACP and the National Council of Christians and Jews.

The Bowling Alley at the "Y" was a favorite attraction. The supervisor of the bowling alley for many years was H. Sylvester Clark (on the far right, wearing white), who became the first African-American city council member in the City of New Castle.

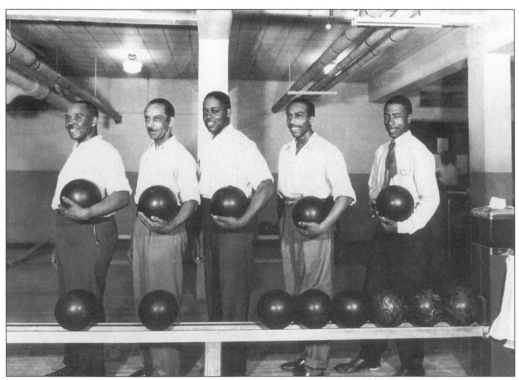

The bowling teams here were renowned. Pictured here is one famous team.

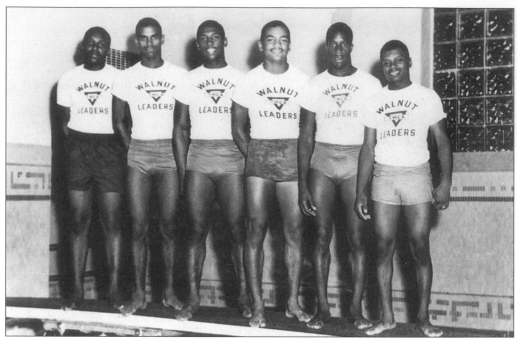

The "Y" leaders pictured, from left to right, are unidentified, Richard Cephas, Arthur Redding, Quentin Sterling, ? Cephas, and Donald Comegeys.

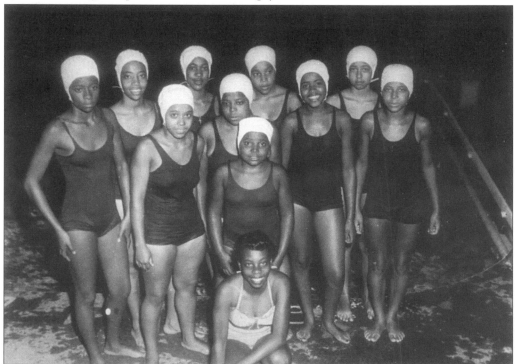

In 1950, Barbara Washam (kneeling) was the captain of the women's synchronized swim team. After graduating from college, Washam worked for the Walnut Street YWCA, eventually becoming the director of health and physical education.

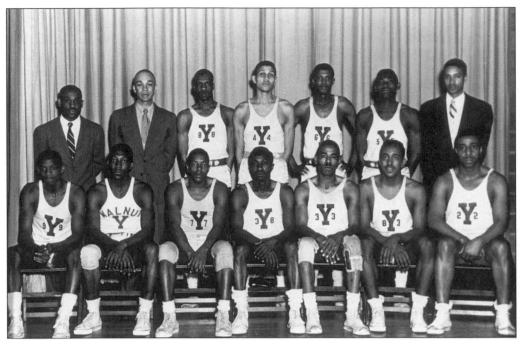

The famous Walnut Street "Y" Big Five basketball team includes the following, from left to right: (seated) Ivory Collins, "Money" Southerland, "Scrappy" Robinson, Charlie Brown, Newell Ruffin, Johnny Sims, and Pete Butler; (standing) Gilbert Jackson, Harry Scott, Walter Russell, William Wales, Rodney Collins, Bob Perry, and Bob Brown (manager). The team won the state Amateur League Basketball Championship.

The Hi-Y Club members, meeting at the home of Mr. and Mrs. William S. Young Jr., are listening to a special guest from Ghana. The YMCA-sponsored group consisted of young men in their junior and senior years of high school. Their advisor, Clyde H. Knotts, is on the far right.

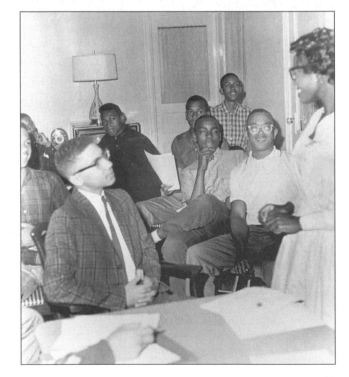

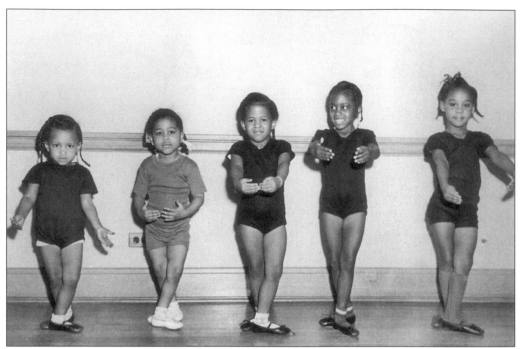

These young girls are part of a 1960s ballet class at the "Y." They are, from left to right, unidentified, Beiley Byrd, Debbie Jackson, Francine Hammond, and Brenda Andrews.

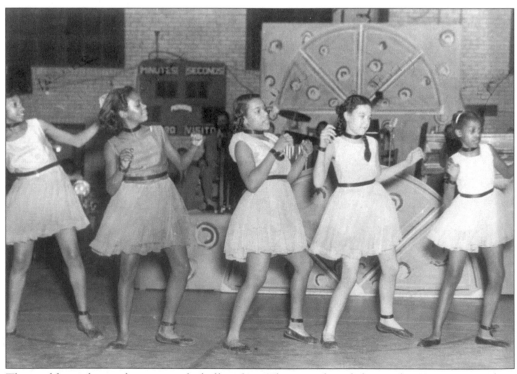

These older girls are also a part of a ballet class. They are, from left to right, Yvonne Bratcher, Pattie Harris, Doris Peaco, Terry Taylor, and Elsie Hackett.

The first home of the YWCA was at 1301 Tatnall Street. The work of the organization began in 1926 with a training course for African-American leaders who wanted to work with teenaged women. During the next several years, Girl Reserves were organized in various communities. The community center, pictured above, was established in Wilmington. Mrs. Gomaster T. Gilbert, president, is credited with moving the organization forward. The First Provisional Committee was organized in 1935 under the leadership of Helen B. de Long. In 1940, the YWCA moved into its new building at Tenth and Walnut Streets with the YMCA.

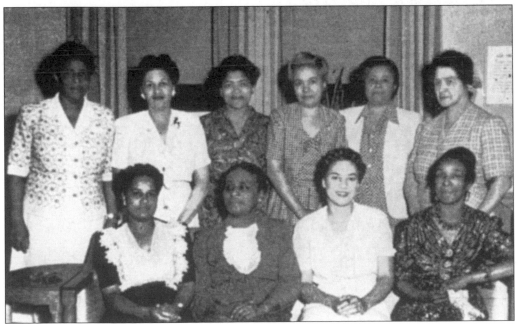

These women were some of the early founders of the YWCA.

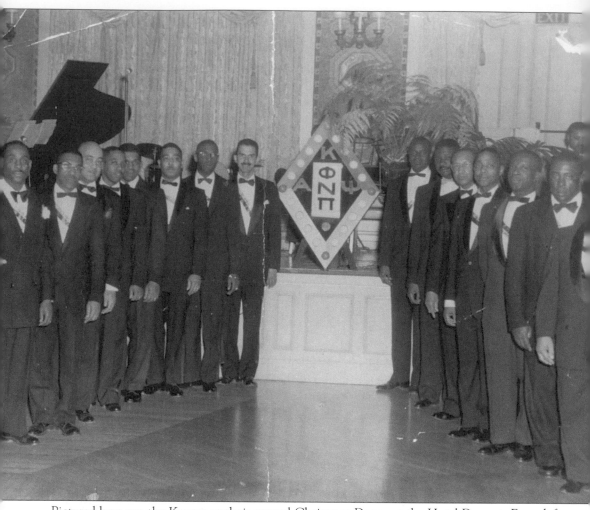

Pictured here are the Kappas at their annual Christmas Dance at the Hotel Dupont. From left to right are Gilbert Jackson, Watson Brown, John Taylor, Donald Evans, Wendall Brown, Phillip Gooden, Edward Fleming, Hilmar Jensen, Richard Fleming, Mitch Thomas, Oscar Smith, Bernard Tildon, Calvin P. Hamilton, Howard K. Toliver, and Leon Fisher.

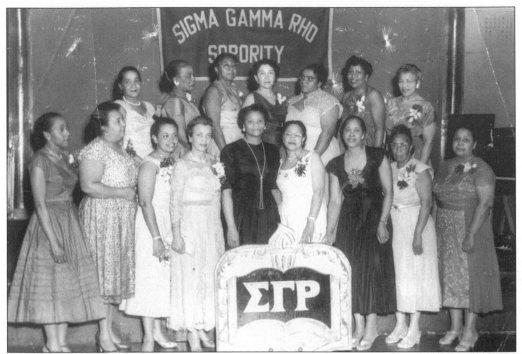

Sigma Gamma Rho Sorority stands for a formal portrait. Pictured are, from left to right, (front row) Betty Evans, Mary Douglas, Tecumseh Rutledge, Louise Brinkley, Helen Wilson, Viola Brown, Reba Evans, Helen Loatman, and Helen Moseley; (back row) Sadie Peterson, Pauline Coleman, Ethel Jackson, Arrie Harrison, Rosa Peaco, Mabel Carroll, and Thelma Young.

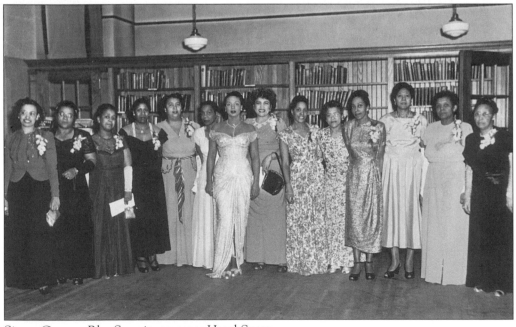

Sigma Gamma Rho Sorority presents Hazel Scott.

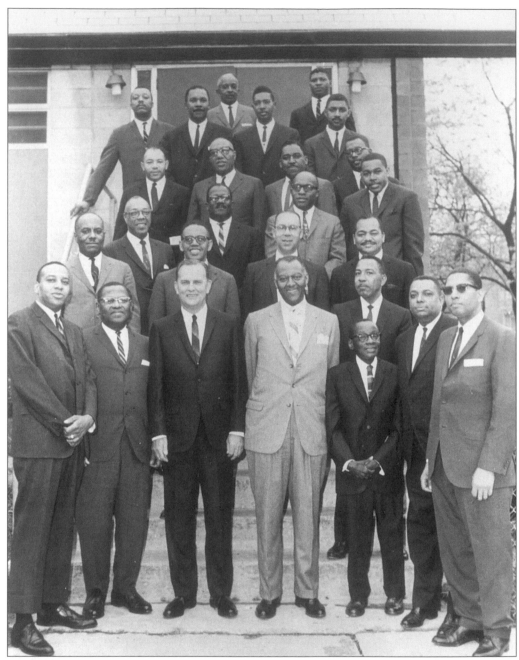

Alpha Phi Alpha Fraternity is pictured here in 1963 and includes, from left to right, (front row) Philip Sadler Jr., Earl C. Jackson Sr., Governor Peterson, Lionel Newsome (national fraternity president) Joseph L. Morris, Allie Carr, Robert V. Nelson, and August Hazeur; (second row) William S. Young Jr., Charles Sims, Forester Lee, Leon V. Anderson, and Quentin Sterling; (third row) Rudolph Koeller, Philip Sadler Sr., Harry S. Young, and unidentified; (fourth row) ? Morris, ? Rice, and Richard Williams; (back row) Donald Brown, Louis L. Redding, and Albert Rowe.

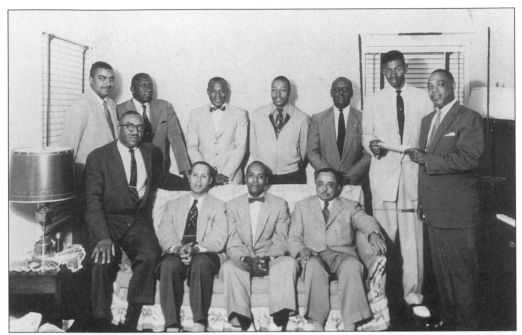

Charles Sims of Alpha Phi Alpha Fraternity presents a scholarship check to a graduating senior. The other members seen here are, from left to right, (seated) Philip Sadler, Dr. Leon Anderson, William Young Jr., and Dr. William Goens; (standing) Wendall Sims, Wayman Coston, Reverend Maurice Moyer, Donald Brown, and George Taylor.

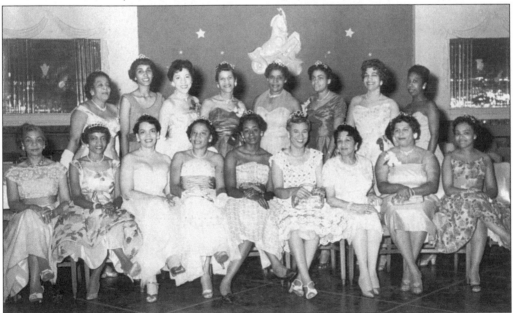

The wives of the men of Alpha Phi Alpha are pictured at a dance at the Rodney Hotel in the 1950s. From left to right are (front row) Mae Coston, Sandy Nelson, Elizabeth Jones, Pearl Sadler, Jackie Overhall, Grace Goens, Pauline Milburn, Katherine Hazeur, and Gretna Hart; (second row) Mary Douglas, Janice Anderson, unidentified, Polly Sims, Cecile Young, Alma Clark, Cleopatra Moyer, and Lennie Lewis.

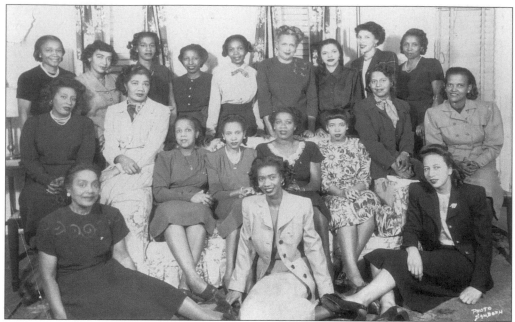

These are some of the early members of the Alpha Kappa Alpha Sorority in 1948. From left to right are (front row) CeCe Henry, Thelma Dickerson, and Helen Taylor; (second row) Elizabeth Crampton, Reba Evans, Madeline Burton, Nannie Waters, Rosa Williams, Delores Lockett, Katherine Young, and Wetonah Barker; (back row) unidentified, ? Evans, Betty Turner, Martha Evans, Venus Johnson, unidentified, Roma Quinn, ? Evans, and Genevieve Wiseman.

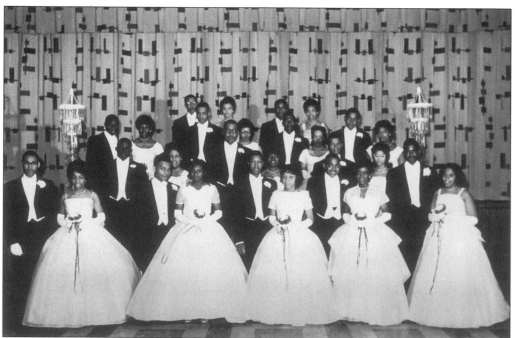

The Alpha Kappa Alpha Sorority presented a debutante ball every year. This one took place in the early 1960s.

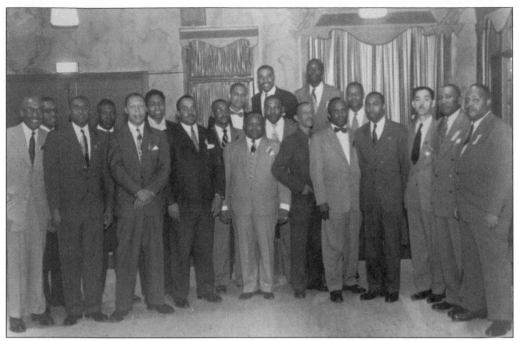

The men of Omega Psi Phi are together for one of their functions in the 1950s. They are, from left to right, (front row) Nick Montgomery, James Hayes, unidentified, unidentified, Dr. Eugene McGowan, unidentified, Dr. Woodrow Wilson, Arnold Emory, James Johnson, unidentified, ? Moses, Eldridge Waters, Ernest Seldon, John A. Taliaferro, and Dr. James Gupton; (back row) unidentified, unidentified, and General Jackson.

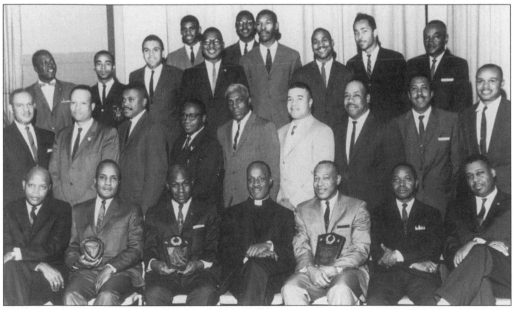

Honorees of the Omega Psi Phi Dover chapter are presented here with the group's Citizen Award.

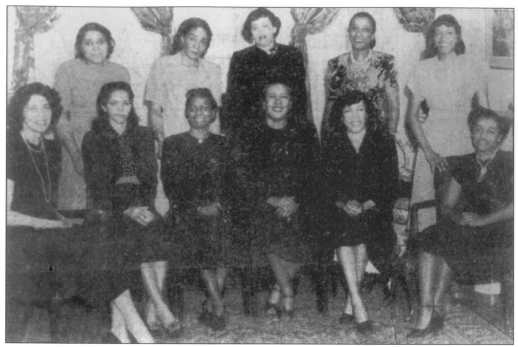

Pictured here are the charter members of Delta Sigma Theta Sorority. From left to right are (front row) Louise Syfax Hopkins, Harriet Seldon, a regional director, a regional director, Allie Holley, and Edith Carter; (back row) Myra Gibbs, Gwendolyn Redding (president), Rosalia O'Neal, Elizabeth Hamilton, and Marjorie Wright Scott. (Not pictured is Grace Goens.)

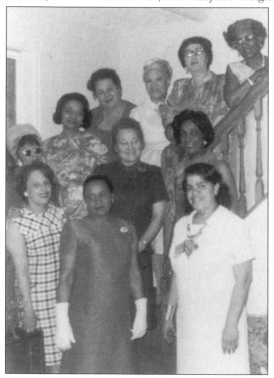

"The Links, Incorporated" is a women's service organization that promotes and engages in educational, civic, and intercultural activities in order to enrich the lives of members and the larger community and to work together to achieve common goals. The Wilmington, Delaware chapter, established in 1948, is the third oldest chapter in the nation. The charter members of the Links are, from the bottom to the top of the stairs, Yvonne Jensen, Jean Jamison, Maurice Christophe, Sara Taylor, Grace Goens, Annie Marks, K. Lorraine Hamilton, "Drops" Montgomery, Alice Brown, Leota Terry, and Libby Hamilton Anderson.

The Barons was a young men's social club known for its dances. Pictured here are, from left to right, (front row) Charles Kent, ? Turner, James Walker, and James Anderson; (back row) William Landon, William Washington, Clarkson Harris, Philip Gooden, and ? Monroe.

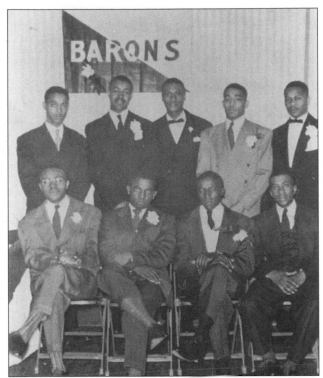

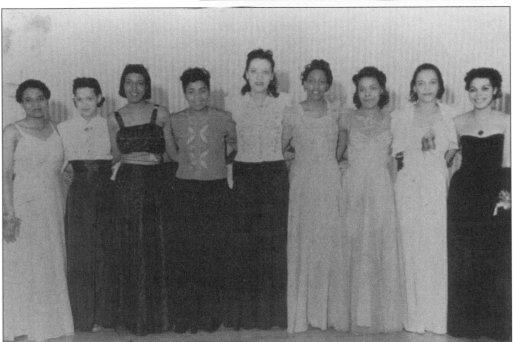

The group of young women in the social club Wil-Lo-Se (short for "Willing Loyal Service") was sponsored by Mrs. Alice Anderson. They are, from left to right, Alice Cunningham, Virginia Holmes, Majorie Wright, Gertrude Henry, Julia Vaughn, Sarah Wright, Tyvolia Gooden, Dorothea Harris, and Eldora Church.

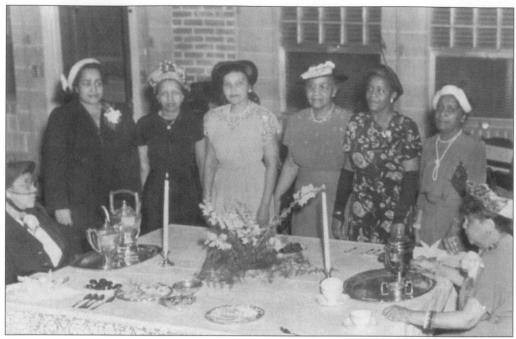

The Carver Garden Club was dedicated to the art of gardening. Here, members enjoying an afternoon tea at St. Matthews Episcopal Church are, from left to right, Edith Johnson, Lillian Brinkley, Ventie Jean Williams, Florence Carrington, Helen Turner, unidentified, C.B. Williams, and Gertrude Henry. (Missing is Molly Fleming.)

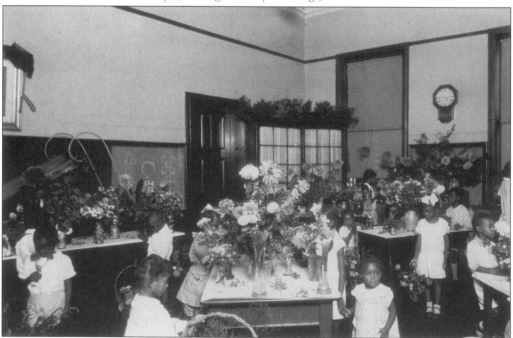

The Carver Garden Club presented flower shows at the local schools. This one is at No. 5 School, and the little boy on the left smelling a flower is Robert Fleming, the son of member Molly Fleming.

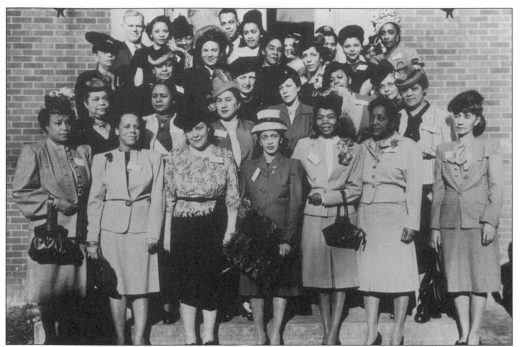

These are the College Women, an organization of college-educated women, who later became known as the University Women.

This is a 1950s picture of the Rho chapter of Phi Delta Kappa Sorority that was organized in 1934 with nine teachers. The group sponsored the first African-American Girl Scout troop in Delaware and the first play center for children in the community.

The Walnut Street YMCA Theater Guild was known for its outstanding productions. This is the 1950 Christmas Party. From left to right are (seated) unidentified, Mary Clark, Jean Anderson, Bill Myers, Luvenia Gray, and Margaret Davis; (standing) Frances Portlock, Alma Hamilton, Janice Anderson, John Russell, Ricardo Madella Morris Levenberg, Stansbury Ferrell, Hilmar Jensen, Yvonne Jensen, David Gray, unidentified, Patsy Williams, Sherman Clark, and Ariel Munce.

Several women organized a Bridge Club, and they are pictured here dressed in their lounging outfits.

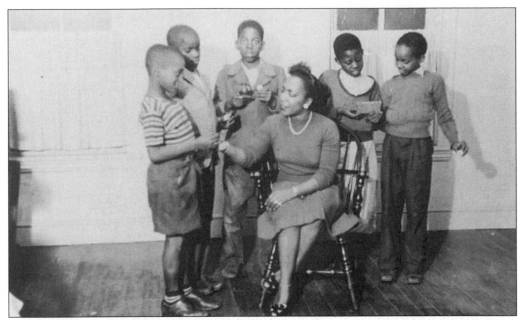

Reverend Arthur R. Jones was known as a progressive minister at Central Baptist Church. In the early 1940s, he organized this after-school program held in a building owned by the church on Eighth and Kirkwood. Rebecca Washington, pictured here, was one of the program's early directors.

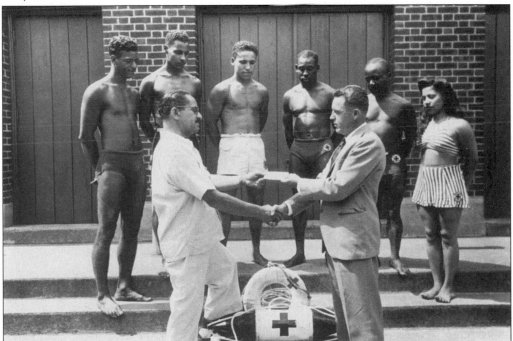

Lifeguards at Kruse Pool are seen here receiving their Red Cross certification. In the foreground are Arthur Wheeler Sr., a Howard High School coach, and Al Rand, a Red Cross instructor. The young people are, from left to right, Frank James, Ralph Ringgold, Arthur Wheeler Jr., Gilbert Jackson, Walter Duckery, and Mary Ann Wheeler.

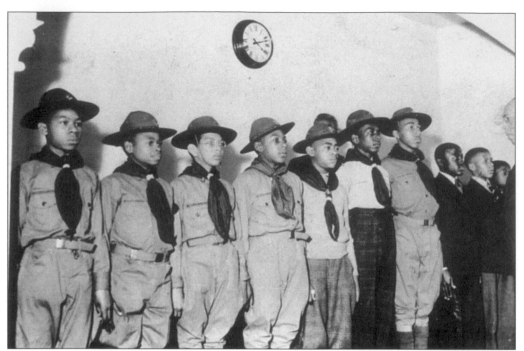

The leader of this 1930s Boy Scout troop is G. Oscar Carrington, a recipient of the Silver Beaver Award—the highest award given to a Boy Scout volunteer.

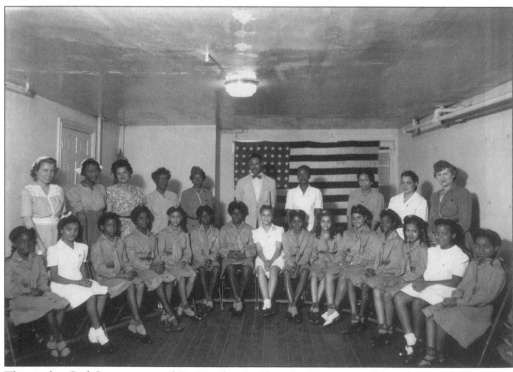

This is the Girl Scout troop of St. Matthew's Church. (Courtesy of the Historical Society of Delaware.)

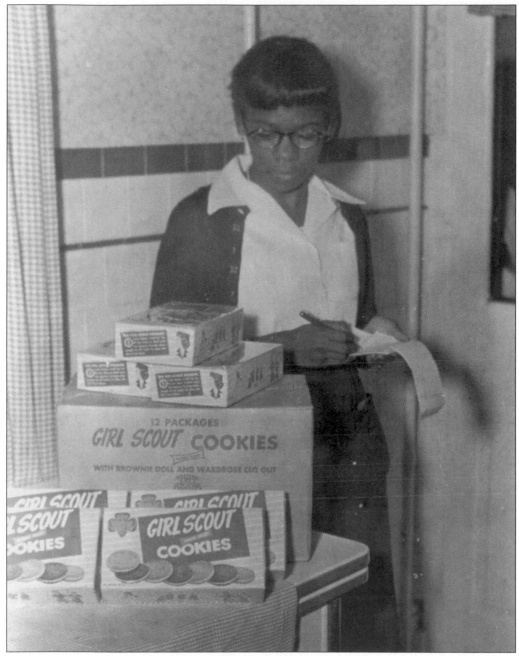

Pattie Harris is tallying her Girl Scout cookie orders. She was a member of the troop that operated out of the Walnut Street YWCA.

Madeline Cooper and a group of friends formed a social club in 1937 known as the Jeudiettes from the French word for Thursday. They later changed their name to "The Women."

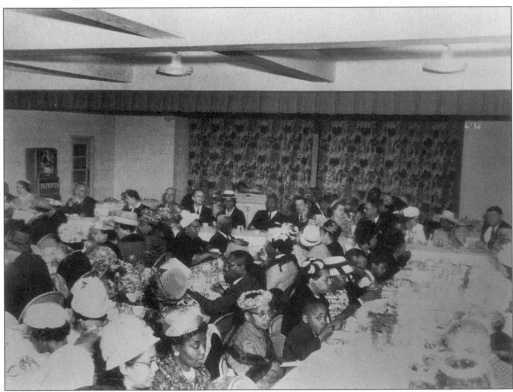

The Community Progressive Club, Inc. was formed in the early 1940s out of the need to provide wholesome activity for the youth of New Castle. The organization sponsored a Boy Scout troop, Cub Scouts, and Brownies. In the 1960s, the club saw the need for early childhood activities and developed a Head Start Program. Pictured here is the group's annual breakfast.

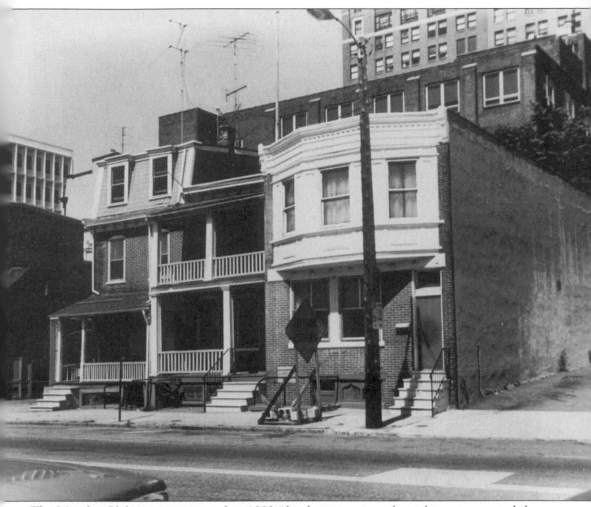

The Monday Club was incorporated in 1893 "for the promotion of social intercourse and the study and discussion of questions of public welfare." Membership in the club was limited to men. The organization was started in 1876 in Wilmington by men who worked as coachmen, chauffeurs, butlers, cooks, and janitors and would stop in a hotel at Front and French Streets for a few drinks and small talk on Monday, their day off. The buildings, pictured above, are where the group still meets today. The Monday Club is the oldest African-American men's social club in Delaware.

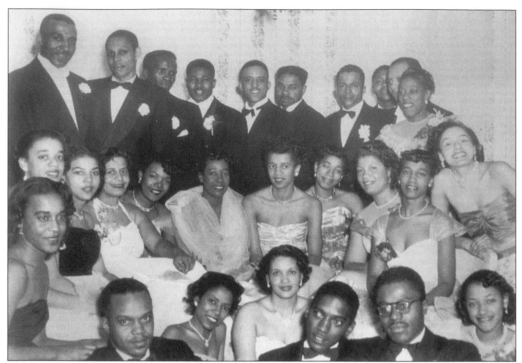

These "Y" adults are gathered for breakfast after a debutante ball. From left to right are (front row) unidentified, unidentified, unidentified, David Clark, James Hayes, and Rella Brown; (second row) Marion Haughton, Odessa Thomas, Helen Holder, Katherine Hazeur, Julia Mayo, Noreen Norris, Vivian Jackson, Mary Clark, Ann Miller, Betty Turner, and Edith Miller; (back row) Theophilus Andrews, Warren Moore, Nathan "Doc" Hill, David Harmon, Leon Brown, Bill Jackson, Sherman Clark, Leon Holden, and Margaret Brown.

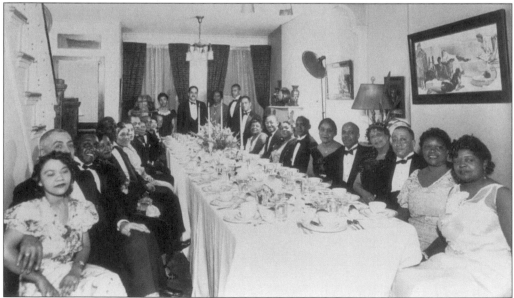

A Wilmington family gave a formal dinner party every year, and this picture was taken at one of those events.

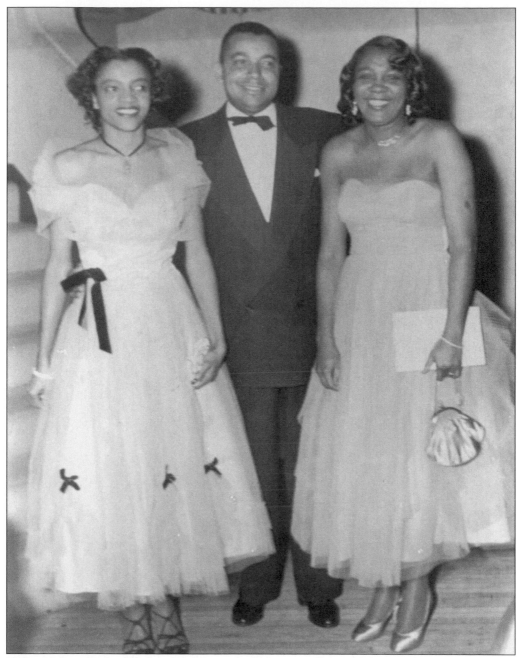

Helen Nelson, Robert Nelson, and Pattie L. Harris are all dressed for one of the many formal events given in the African-American community in the 1950s.

Mitch Thomas joined the staff of WILM radio in 1952. Three years later, he joined WDAS in Philadelphia. From 1957 to 1959, Thomas hosted his own television dance show called *The Mitch Thomas Show*.

One of the most popular dancers on the show was Charlestene Lewis. She was known as "Miss Cha Cha."

Six

THE ARTS

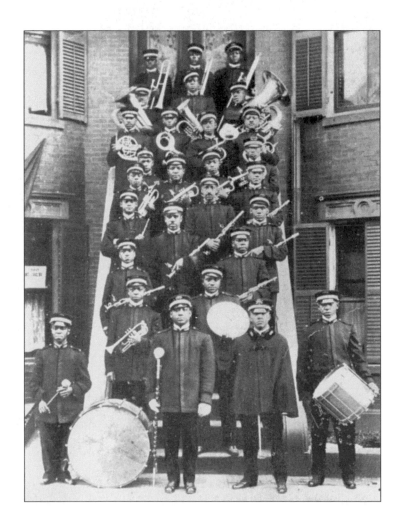

The Odd Fellows Band was an early musical group. This picture was taken shortly after World War I.

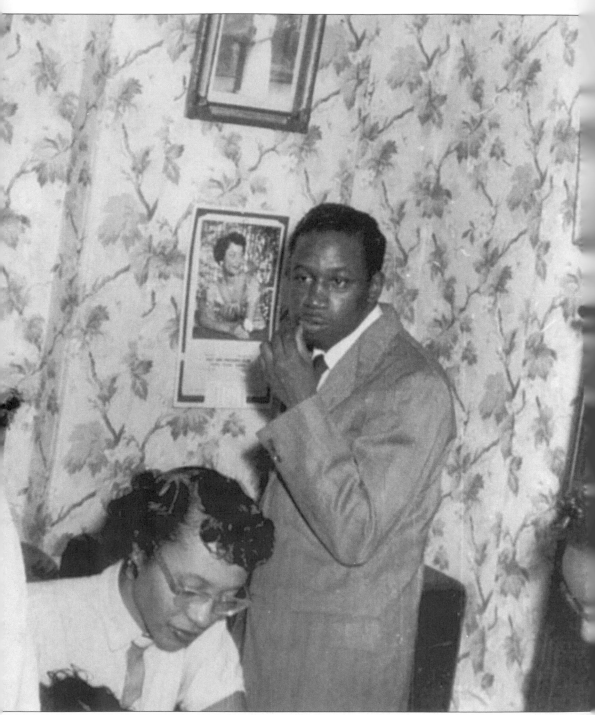

The is one of the rare informal pictures of the famous jazz trumpeter Clifford Brown as he relaxed from playing at his mother's home during a family birthday party. Seated in front of Clifford is family friend Jean Lewis. Clifford joined Lionel Hampton's Band in 1953, and Art Blakey's and Max Roach's in 1954. Clifford was killed in a car crash two years later on the Pennsylvania Turnpike. Delaware and the nation mourned his loss.

Robert "Boysie" Lowery taught jazz for over 50 years. His students included Clifford Brown, Poppa "Dee" Allen, and Gerald Pruce.

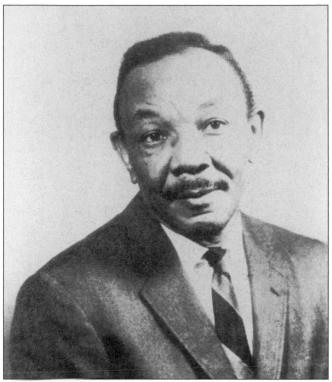

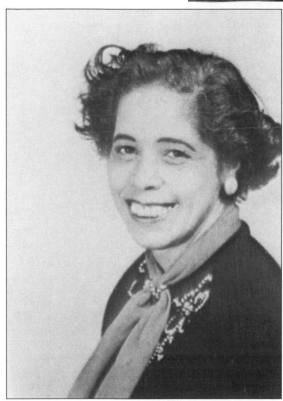

Mildred T. McGowan was a music educator, a musicologist (collecting the rural music of African Americans in the South), and a composer. She is highly revered for her diverse musical talents.

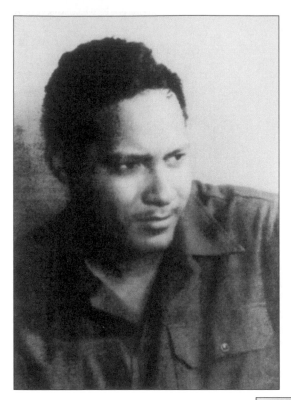

Edward L. Loper Sr. is the most renowned African-American artist in Delaware. His vibrant work is influenced by Cezanne and El Greco. However, it was his friend Horace Pippin who inspired him to "see" differently. He is sometimes called "The Prophet of Color," and his work is housed in major museums and cultural institutions throughout the United States.

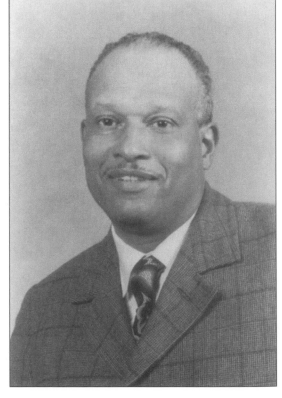

Theodore E. Wells I was a painter and an art educator. The national office of the Omega Psi Phi Fraternity commissioned him to paint the portraits of the group's four founders. This work was unveiled in Washington, D.C., in 1964 at the dedication of the national headquarters. Wells was listed in *Who's Who in American Education*.

Percy Ricks, an artist and art educator, spent his career teaching in public schools throughout Delaware. In 1941, as a student under James Porter at Howard University, he painted a mural at the YWCA. Later, Ricks used that same talent as a graphic artist in the U.S. Air Force. His life has been spent encouraging young people through art.

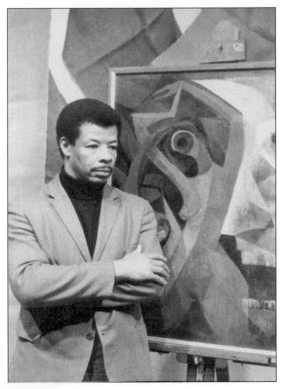

Dorothy Copper describes herself as a painter, not an artist. She creates wonderful still life compositions, portraits, and landscapes.

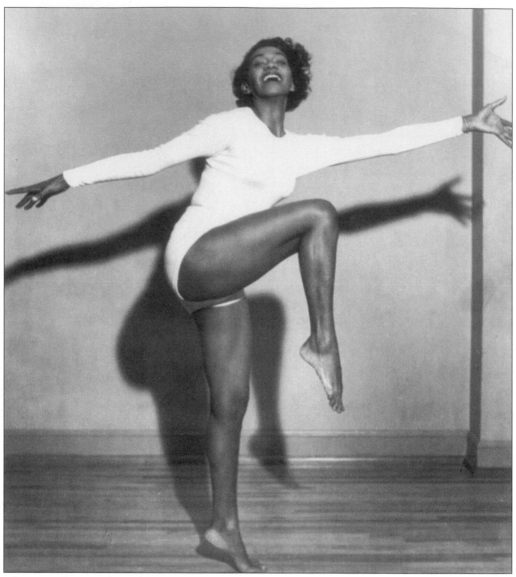

Alveta Hudson graduated from Howard High School in 1940 and then continued her studies at Howard University. She later joined the Katherine Dunham Dance Company. Katherine Dunham is a well-known African-American choreographer, anthropologist, and dancer who studied in the Caribbean and incorporated African and Caribbean dance forms in her choreography. She formed her dance company in 1940 and The Dunham School of Dance in 1945 in New York City.

Seven

SPORTS

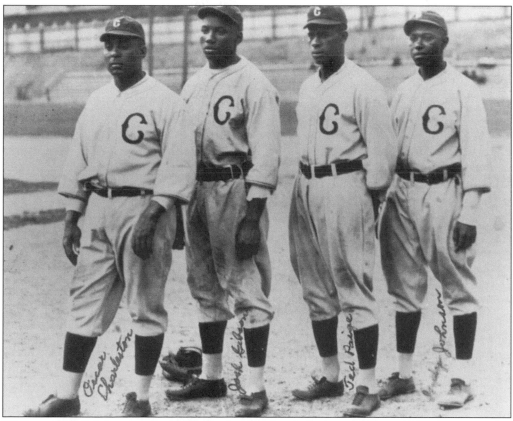

William "Judy" Johnson played Negro League baseball from 1923 to 1937. He earned a reputation as one of the best third basemen in the league and is best remembered as a member of the Pittsburgh Crawfords. He was a gentleman both on and off the field.

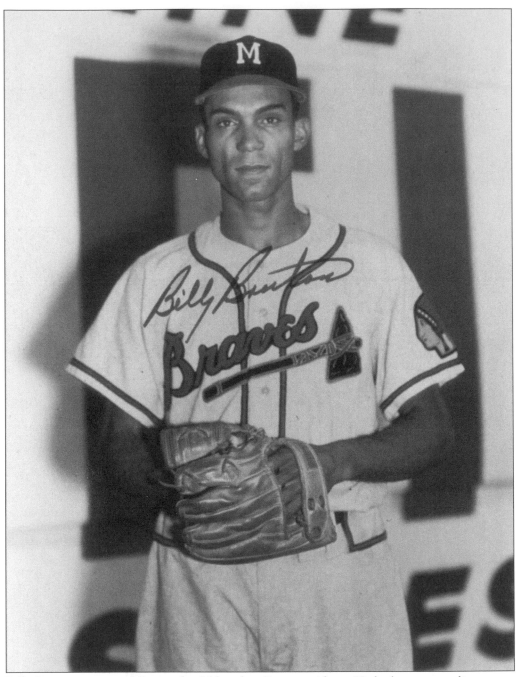

Billy Bruton is pictured here in his Milwaukee Braves uniform. He had an outstanding career with the Braves and was a hometown hero in Delaware.

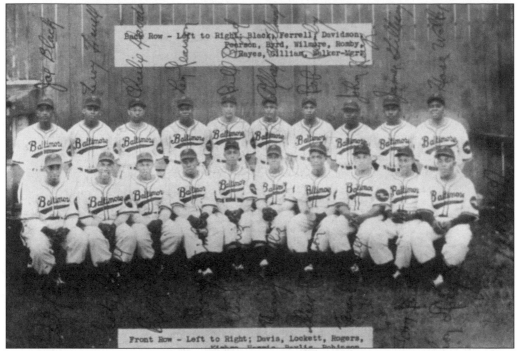

Back Row - Left to Right; Black, Ferrell, Davidson, Pearson, Byrd, Wilmore, Romby, Hayes, Gilliam, Walker-Mgr.

Front Row - Left to Right; Davis, Lockett, Rogers,

Leroy "Toots" Ferrell had a brief career with the Baltimore Elite Giants. He is pictured standing, second from the left, next to Joe Black.

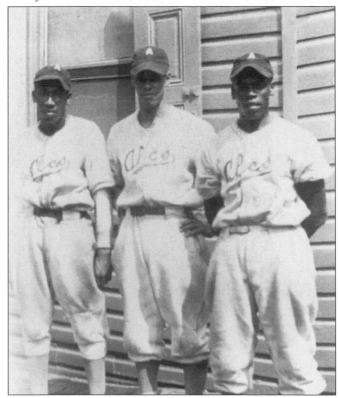

The three members of the Alco Flash baseball team pictured here are, from left to right, Charles Brown, James Church, and Adolphus "Dirt" Jones.

This is a 1940s picture of the Milford Yanks.

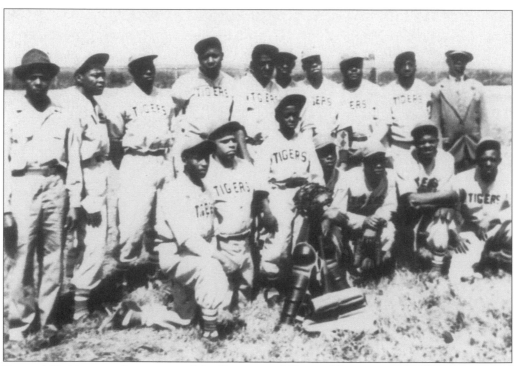

Bernard Pinkett was the mascot of the Buttonwood Tigers. However, it was Handy Hayward who managed the team for three years.

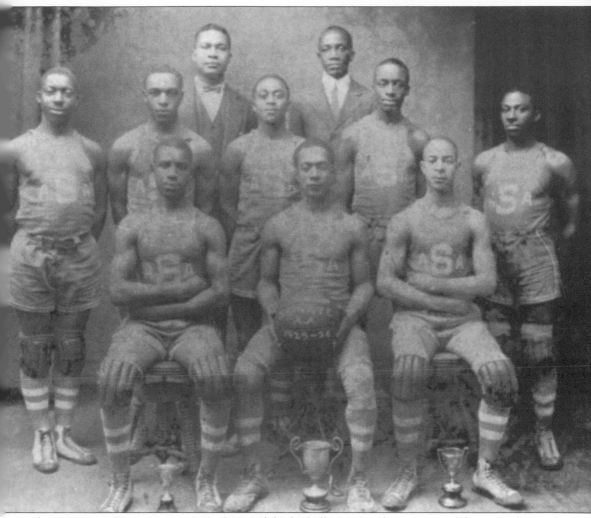

The Senate ACs were a semi-professional basketball team and are pictured here in their 1925–1926 season. Dr. Cuff and Samuel J. Ambrose (standing in the rear) coached the team, whose members included Stanley Jackson, Lloyd Batson, Gilbert Jackson Sr., Gigg Loatman, Andrew McFarley, Maurice Raison, Clem Hollis, and William Goul.

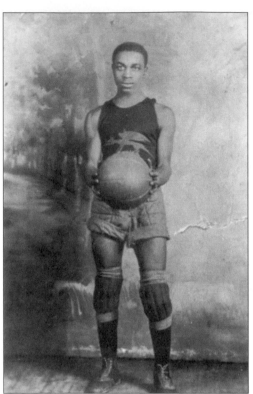

Posed here is Andrew McFarley from the Senate basketball team.

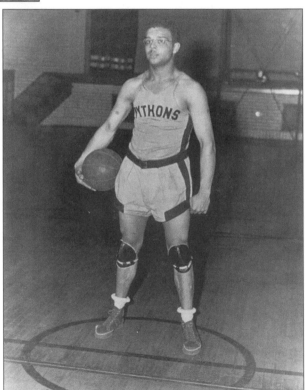

Robert 'Bobby" Davis was one of the players on the Pythons team.

These are the men of the Pythons basketball team.

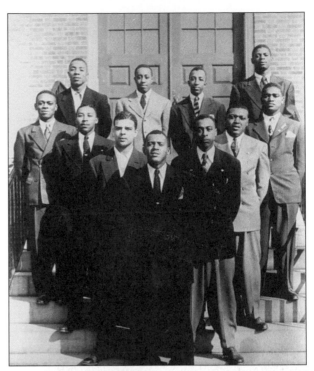

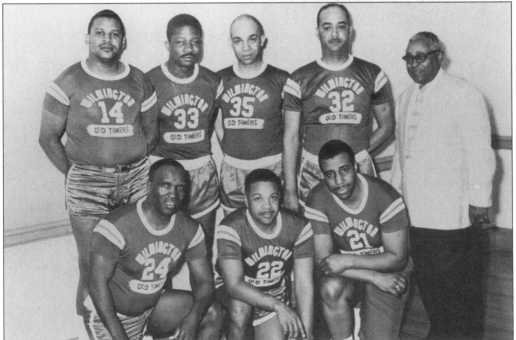

This is a late 1950s picture of the Wilmington Old Timers. Pictured, from left to right, are (front row) Nathan "Doc" Hill, Willard Jones, and Pete Butler; (back row) "Toots" Ferrell, Mitch Thomas, Harry Scott, and June Evans. The team's sponsor is Wilmer Allen (in white jacket). Allen was the owner of the Ebony Inn, a jazz club, which featured well-known artists from around the country.

Lou Brooks was a heavyweight boxer.

Individuals, such as Madeline Burton, had time for leisure sports like tennis.

Eight
MILITARY INVOLVEMENT

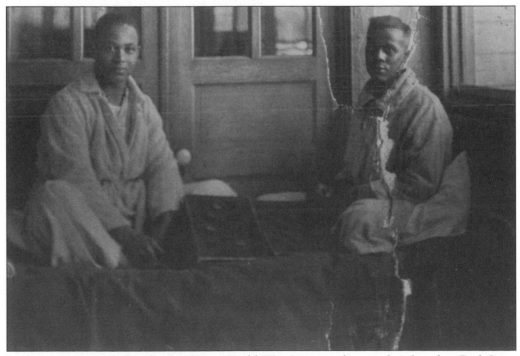

Littleton Van Mitchell, who fought in World War I, is seen here with a friend at Red Cross General Hospital #19 in Oteen, North Carolina.

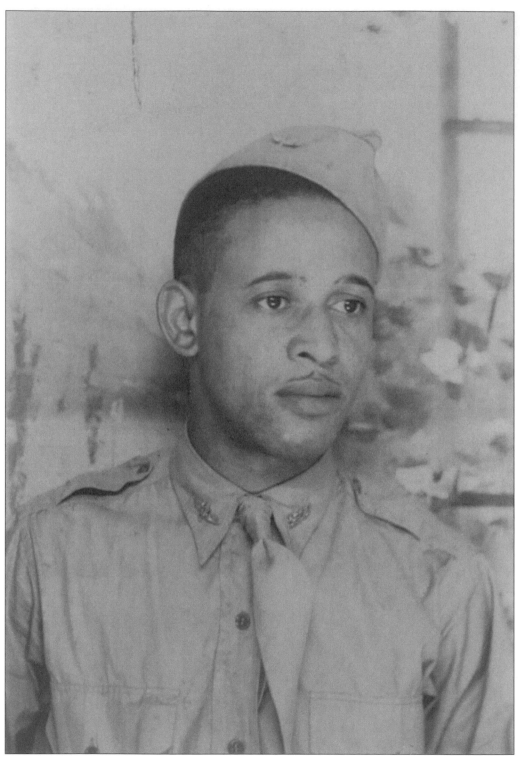

Following in the footsteps of his father, but taking a slightly different path, Littleton P. Mitchell was chosen to be one of the select Tuskegee Airmen.

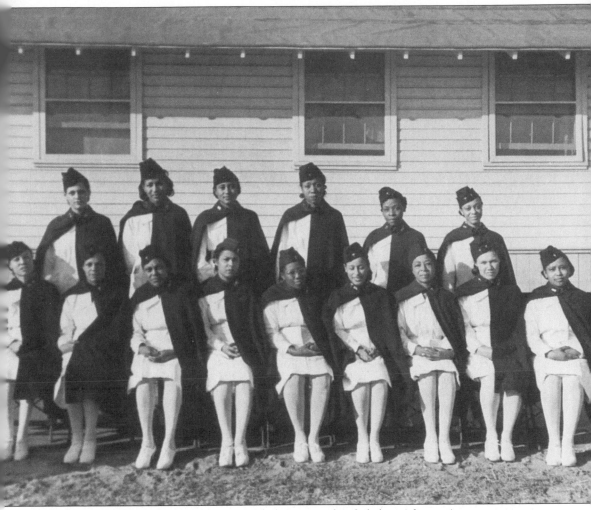

In 1941, Eleanor Roosevelt and nurse Mabel Stauper decided that African-American nurses were needed in the army. Forty-eight African-American nurses volunteered to serve for one year at a rate of pay of $70 a month; twenty-four were assigned to Fort Bragg. Daisy Evans (Wingfield), a 1935 graduate of Howard High School, was one of these volunteers. Then the war began, and the women had to remain in service. Daisy stayed and eventually attained the rank of captain. Here is a picture of some of the women stationed at Fort Bragg. (Daisy Evans is not pictured; however, her friend Elva Jones Dulan, who eventually moved to Delaware, is standing second from the left.)

Howard Toliver was stationed in Southampton, England.

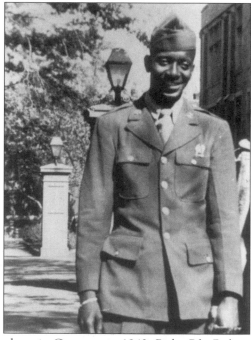

Left: Gilbert Jackson (first soldier on left) is seen here in Germany in 1943. *Right:* Pfc. Robert Fleming was stationed at Fort Dix but later went on to become the first African-American postmaster in Townsend, Delaware.

Lorin P. Hunt was a second lieutenant who, upon leaving the Army, joined the Army Reserves, eventually earning the rank of major.

Jane Boardley, seen here in 1949, joined the Women's Army Corps (WAC).

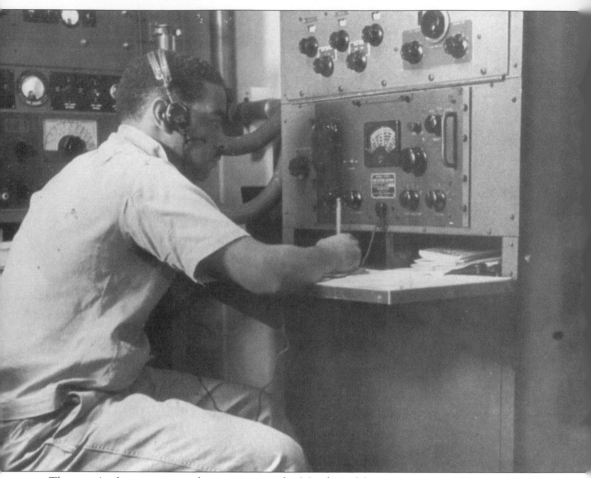

Thomas Anderson was a radio engineer in the Merchant Marines.

Nine

THE WORLD OF WORK

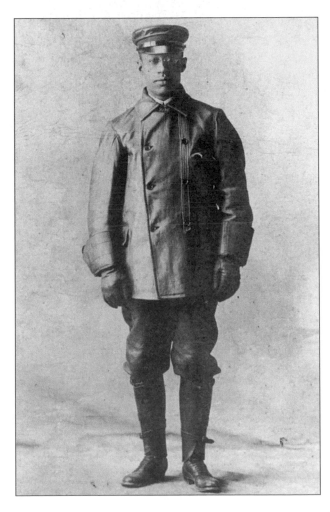

George Benson is pictured here in his leather chauffeur's uniform.

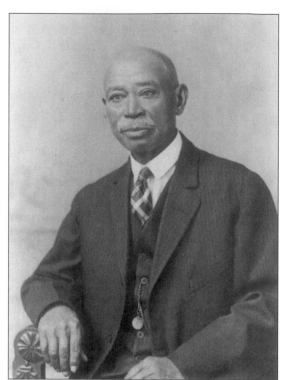

John H. Benson was a coachman and a charter member of the Monday Club.

George W. Cooper was also a coachman.

William James Ross was a courier for the Central National Bank located at 501 Market Street. He also served on the Absalom Jones School Board.

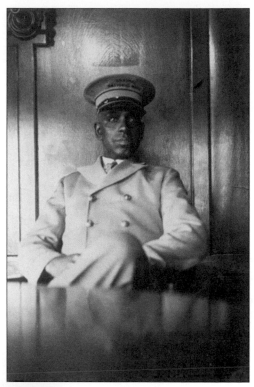

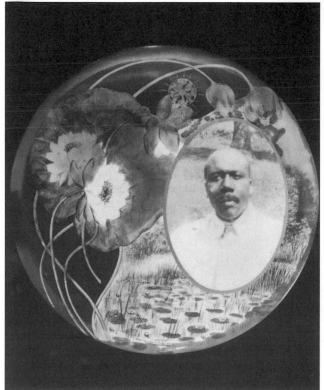

Early in the history of the state, the majority of rural African Americans were tenant farmers. Families such as the Congo family in Smyrna and the Jones family in Mt. Pleasant owned sizable tracts of land. Frank Jackson, pictured here in 1880, owned a farm in Smyrna.

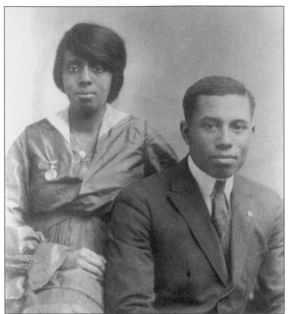

William S. Young, pictured here with his wife, Alephia, was one of the first African-American foremen with the Pennsylvania Railroad (PRR). He earned a PRR heroic service medal for saving a fellow worker's life at the risk of his own. The railroad featured William Young and his family in an advertisement that they ran in several publications.

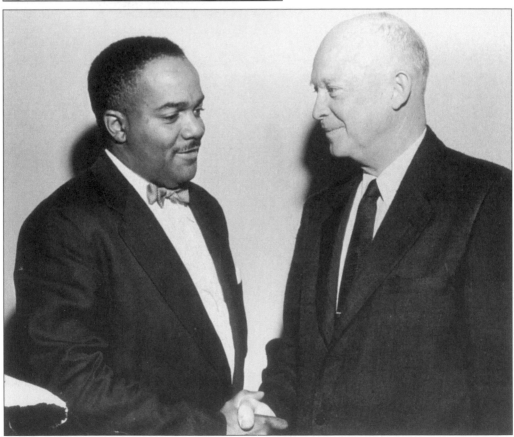

Dr. Woodrow Wilson was a dentist in Wilmington. He also served on the Delaware State Board of Education. Here he is pictured shaking the hand of former President Dwight D. Eisenhower.

Some of the best jobs to be had were with the civil service. In Delaware, many African Americans with college degrees had to turn to the postal service for work. Patrick Turner earned a degree from Drexel University and worked as a letter carrier.

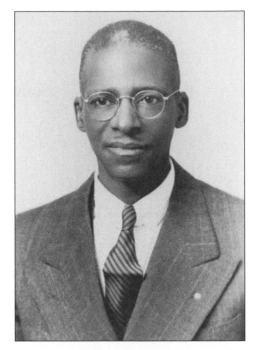

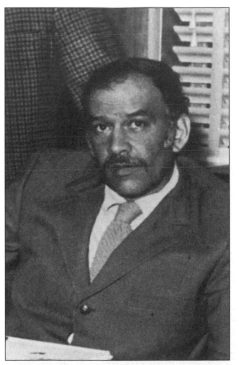

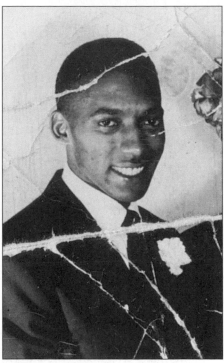

Left: For a long time African Americans working for the postal service in Delaware were relegated to the position of letter carrier. Harrison Hackett and Elsworth Mercer were some of the first to move up to the rank of clerk. Years later, Lennox "Lacy" Jackson (pictured here) was promoted to supervisor. *Right:* David Clark was the second African American to be promoted to supervisor, and Irving Carty followed him.

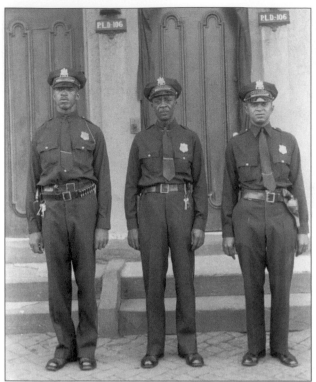

The following individuals, pictured from left to right, were the first African-American police officers in the City of Wilmington: Ralph Harris, Lockwood Purnell, and Robert Fleming.

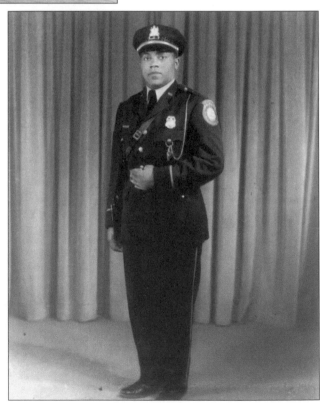

Eugene C. Petty was the first African-American police officer in New Castle.

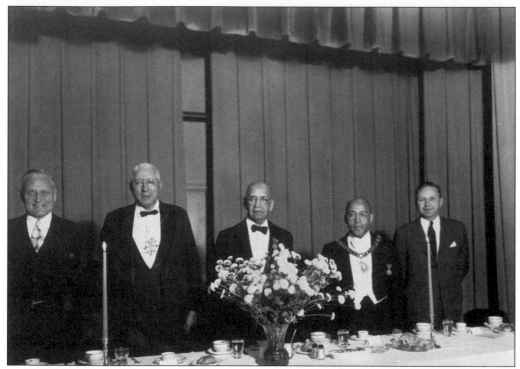

In the field of medicine no one stands out like Dr. Conwell Banton (pictured center, next to Grand Master George Oscar Carrington). Dr. Banton established the first African-American tuberculosis sanatorium in the nation; it was known as Edgewood. The doctor's career in Delaware spanned 51 years.

Dr. Winder Laird Porter left private practice to become a physician for the Delaware State Board of Health. He later became the director of the state's Venereal Disease Control Program.

Dr. Patricia Turner was the first African-American psychiatrist and the second female, African-American physician in the state of Delaware. In addition, she was the first African-American physician to be appointed to a hospital staff.

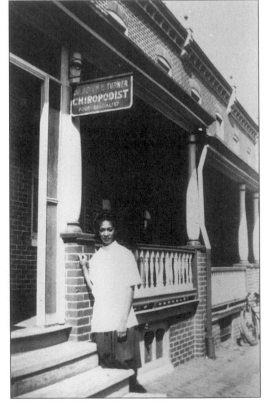

Dr. Helen Turner, sister to Dr. Patricia Turner, was the first female, African-American physician in the state of Delaware. Her area of specialization was podiatry, in which she earned degrees in both medicine and surgery. She went into private practice in Wilmington.

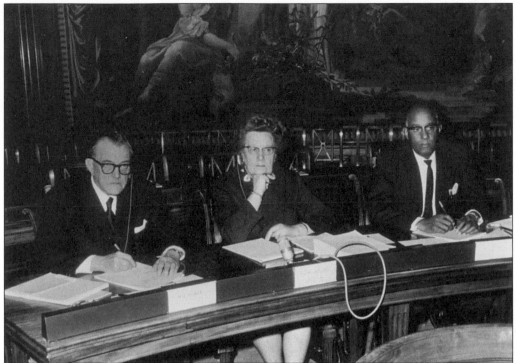

The United Nations (UN) proved to be a calling for several African Americans from Delaware. Eldora Church worked as a secretary at the UN in New York. Reginald Bruce also served at the UN in New York. Leonard J. Young, pictured here, worked with both the International Labor Organization in Switzerland and the United Nations Development Program in Kenya and Suriname.

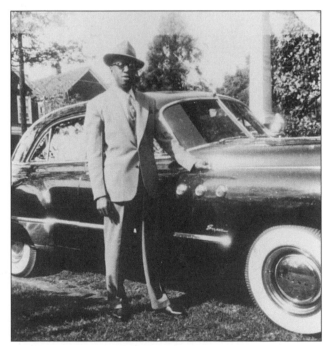

Edward Fleming was encouraged by Leonard Young to join the United Nations. His advice was taken, and Fleming was stationed in India for several years.

Left: Theophilus Nix became the second African American to be admitted to the bar and the first to serve as a criminal prosecutor in the municipal court in the City of Wilmington. *Right:* Sidney Clark was the third African American to be admitted to the bar and the first African-American judge in the history of the state.

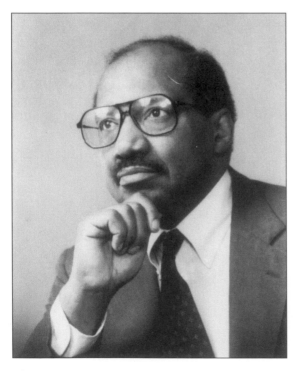

Leonard L. Williams was the fifth African American to be admitted to the bar. He joined the law practice of Louis L. Redding and was later appointed an associate judge of the municipal court.

Dr. Eugene McGowan was the first African-American school psychologist in the state of Delaware. He also served as chairperson of the Delaware Leadership Council, a politically oriented civil rights group.

Left: Calvin P. Hamilton was the first African-American architect in the state. He had a long-standing and successful business in Wilmington, and he designed many of the buildings in the area. *Right:* Though A. Roland Milburn and Oscar Smith were some of the early pharmacists in the state, August Hazeur (pictured here) was one of the first to work for some of the locally and nationally owned drugstore chains.

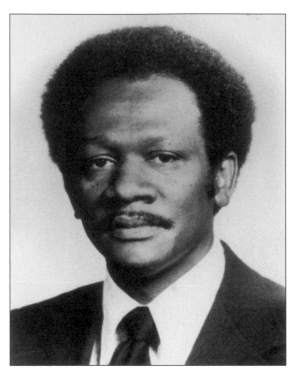

Charles H. Debnam made major contributions in the field of mental health. While working at the Delaware State Hospital, he instituted the first community mental health program. He later initiated the concept of state service centers.

James H. Sills Jr. became the first African-American executive director of the Peoples Settlement Association. Years later he was elected the first African-American mayor of Wilmington.

Ten

BUSINESS

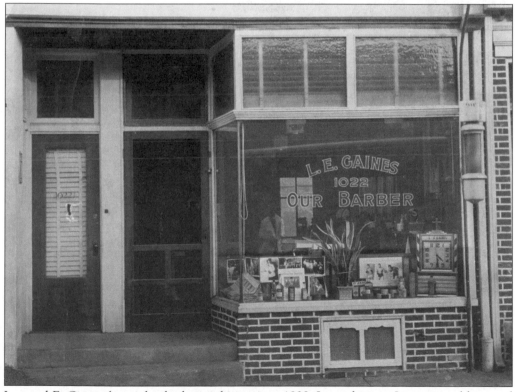

Leonard E. Gaines began his barbering business in 1933. Later, his son Leroy joined him and their slogan became "We need your head to run our Business." They had a modern facility that was air conditioned in the 1950s.

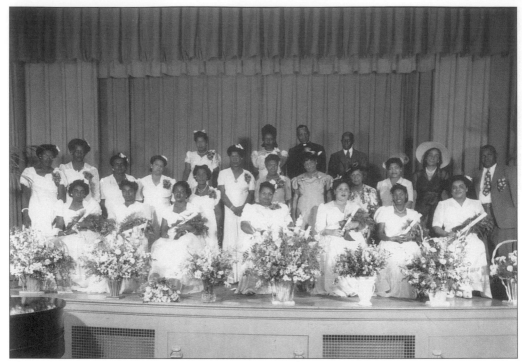

This is the graduating class of the Dora Lee School of Beauty Culture. Madame Dora S. Lee was the owner of the establishment, which operated at 314 East Tenth Street. (Courtesy of the Historical Society of Delaware.)

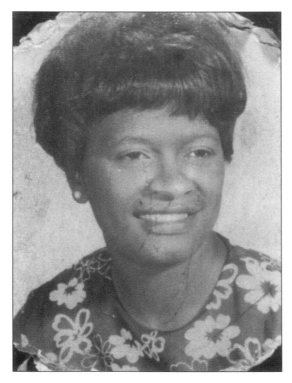

Sylvia Mack operated her first beauty shop out of her home but later opened a state-of-the-art establishment in downtown Wilmington.

Bell's Taxi Cab company was the only African-American company of its kind in the 1930s.

This is a picture of the Gray Undertaking Establishment, Inc. in 1935. The funeral home was established by Charles H. Gray and became one of the leading undertaking businesses in the city of Wilmington. Bells Funeral Home was another prominent undertaking establishment.

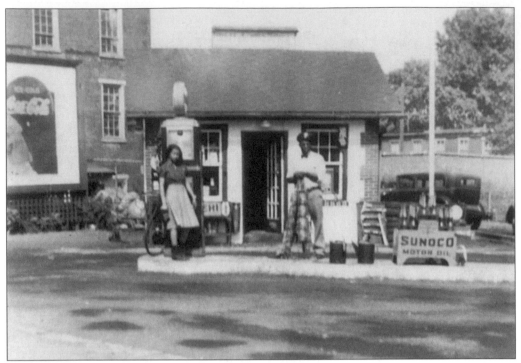

Fletcher White owned a Sunoco Filling Station in downtown Wilmington. Pictured here are Helen Brady and Mr. Bowie.

Theophilus Andrews, one of the most successful business persons in the contracting field, started his trucking business in the 1950s and eventually expanded to the highly successful Andrews Paving Company. Andrews also was active on the board of the Walnut Street YMCA and the Lions Club.

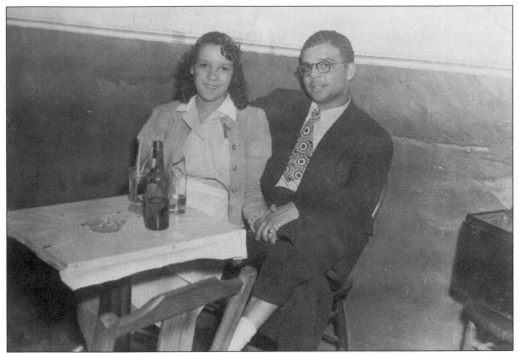

There were several nightclubs in Wilmington in the 1940s, including the Spot, the Baby Grand, and the Embassy Room. Olivette Davis, a waitress at the Spot, is seen here taking a break with her husband, Bobby.

African Americans owned many kinds of businesses. Here, Cora Pritchett (Toliver) stands outside of Alex's Record Shop in the 800 block of Walnut Street.

AFRO's Book Reviewer Himself Noted Author

AFRO readers who, for one reason or another, find it difficult, if not impossible, to keep up with many new books, will be happy to know that J. Saunders Redding, whose column, "A Second Look," has appeared in this paper for several years, is now devoting his columnto book reviews.

Mr. Redding, professor of creative literature at Hampton Institute and an author in his own right ("No Day of Triumph," and "To Make a Poet Black), is well qualified for his new task.

His "No Day of Triumph" won the 1943 Mayflower Cup awarded by the Mayflower Society for the best book written by a resident of North Carolina.

Prof. Redding is not only a brilliant writer, but also has traveled extensively studying problems affecting the social and economic life of colored Americans.

Native of Delaware

A native of Wilmington, Del., Mr. Redding attended Lincoln (Pa.) University and Brown University from which he received the Master of Arts and Ph.D. degress. He has taught at Elizabeth City (N.C.) State Teachers' College and is presently teaching at

Won Prize Award

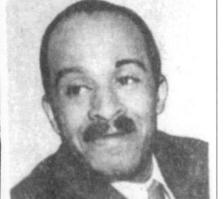

J. Saunders Redding, the brother of Louis L. Redding, was not in business but was about the business of preserving African-American history. He was a noted scholar and the first African-American faculty member at Brown University. His publications include *No Day of Triumph* and *To Make a Poet Black*.